Dear Sue & Randy,

May Christmas 2000 be filled with love, joy and "angels."

Love,
Hil & Dee

# GUIDED BY ANGELS

# GUIDED BY ANGELS

DIVINELY INSPIRED PAINTINGS BY

*Amanda Dunbar*

LONGSTREET PRESS

ATLANTA, GEORGIA

Published by
LONGSTREET PRESS, INC.
2140 Newmarket Parkway, Suite 122
Marietta, GA 30067

Printed in the United States of America

1st printing 2000

Library of Congress Catalog Card Number: 00-102697

ISBN: 1-56352-635-2

Visit Longstreet Press on the World Wide Web at:
www.longstreetpress.net

Jacket and book design by Burtch Bennett Hunter

*A Brush with Angels*

I simply cannot put into words the way Amanda's father and I felt the first time we viewed her paintings in a crowded little studio at her middle school in Allen, Texas. It was barely a few weeks after we'd begun sending Amanda to her after-school art class with a bag of paints and brushes in hand. She had only taken the canvas in with her for the first time earlier that very week. Yet her teacher had already requested a meeting with us.

Not in our wildest imagination could we have been prepared for what we saw. What immediately caught my eye were three paintings, one larger and two smaller ones leaning against a cupboard. There were another two, still in progress, on shaky aluminum easels nearby. They were breathtakingly beautiful. They were paintings by Amanda.

Although these paintings were beautiful to look at, they seemed to contain something more. The astounding feeling Amanda had captured went beyond the complexity of her compositions, her mastery of color, and her brushwork. These pieces were sophisticated in technique yet simple in message. How was it possible that our thirteen-year-old child could paint such works? Amanda had never expressed a desire nor shown an aptitude for art before this. It had been somewhat of a surprise to us when she decided to take the art class in the first place. Until that time, Amanda's focus had been on literature. From the time she was very young, she would close herself off from the world and immerse herself in books for hours on end. We had often imagined that one day Amanda might be a writer.

Upon our return home, Amanda met us at the door. She searched our faces for some kind of feedback about the meeting. There was simply nothing to say. We were so overwhelmed and confused that all we could do was give her a big hug and affirm that she had done a good job in her class and that we were proud of her. "I love painting," she would say repeatedly. "I really love it!" And paint she did.

Over the summer, Amanda would take her supplies to school and arrive home exhausted but exhilarated. We had never seen her like this before. She was truly happy and at peace. Occasionally she would accompany me on a trip to the art supply store, where she could hardly contain herself. She would gather a handful of brushes, fan them out like a bouquet of flowers, and remark on how beautiful they looked. "I just love new brushes, Mom!" she would say. She would lay tubes of paint out on the kitchen table so that she could see the myriad of colors at a glance. The canvases began to accumulate. The painting was becoming more and more a part of her life—and it was quickly becoming part of our lives also, whether we were ready or not.

The paintings were hauntingly beautiful images of children at play and of special family events. Many of them contained fragments from our personal lives. She had captured moments and places that were special to us all. Each piece conveyed a story or message of gentle times. Amanda painted children of different racial and ethnic backgrounds without even seeming to notice. She painted all children and all families. Who were these people and why was she painting them? How did she choose the colors? How was she able to create such life and passion while mastering the technical aspects of perspective and scale? Her response to such queries was always simple: "My angels tell me what to paint. It is something bigger than me that works through me. I'm only the instrument. Some of these people just want to be painted. I don't know who they are or why they need to be painted. They just do. Someone, somewhere will know why. I believe everyone has angels; I just listen to mine."

## A Brush with Ben

Clearly out of our league when it came to the question of what to do with Amanda and her art, Ken constructed a Web site for her. Among the varied e-mails came a message that sparked our interest from a publisher whose name we recognized, due to his success in representing another young girl, Alexandra Nechita, and her amazing art: Ben Valenty of New Millennium Publishing. Since Ben is considered an authority on gifted children in the visual arts, it was certainly a surprise to receive an unsolicited message from him when we had not even submitted a portfolio. And he had only had the pictures from Amanda's Web site to look at! After much thought and deliberation, we sent him photographs of Amanda's work so that he might critique them and give us a place to start in helping our daughter. It was our thought that she need never know if her work were rejected. However, the next correspondence we had with Ben was by telephone, and it was not a rejection.

In the meantime, Amanda painted. Every available inch of space in the new studio was soon covered by canvases in various stages of completion. She was pleased that Ben liked her work, but seemed relatively unphased by discussions about her potential career. Her eyes remained focused on the new paints and canvases that were arriving almost daily from the catalog company we had discovered. Her desire remained simple: "I just want to make people happy with my paintings, that's all."

During this time, we took two museum trips that became significant events in Amanda's artistic life. The first was to a Monet exhibit. Amanda's art history teacher had encouraged her to see it to experience the paintings of a French Impressionist master. Amanda of course enjoyed it thoroughly and chatted about it nonstop all the way home. The exhibit had been a technical lesson for her. In the car, she made a passing comment about understanding what Monet had been trying to achieve with regard to light and color in his paintings. I remember thinking, "You are fifteen years old. How can you only be fifteen years old?"

The second museum visit was a more profound experience. Her teacher had suggested that she might enjoy an upcoming exhibit of Renoir's portraits. Amanda begged for weeks to pin down a date to go. Unlike her last trip, this time she appeared solemn and thoughtful. She spent several hours on her own, away from the tour groups, examining each of the paintings over and over. "I know this man," she said, in reference to Renoir. "I know him. I know what he was thinking when he painted this painting and I know these people. I feel like we've met and the places seem familiar, too. I have met this man somewhere before and he knows me, too. Look—even his brush strokes are similar to mine. I feel like I am at home here with these paintings. But how can that be?"

The rest of us had to insist that Amanda get into the car when the time came to leave. We were all tired, but she could have easily stayed the night. It was a quiet ride home. Amanda's thoughts appeared to be a million miles away. She had the slightest little smile on her face and she just appeared peaceful. For reasons we may never understand, I thought, our daughter has been chosen to release messages through her paintings. These messages need to get out to the people they were intended for. I realized that Amanda's paintings were not ours to keep—they were meant for others.

Amanda would find her way back to the Renoir exhibit at least two more times before it closed. And we placed an important call to Ben Valenty. We agreed to begin helping Amanda show her work to the world. We had no idea that Amanda and her paintings would change all of our lives so quickly.

### A Brush with the Unknown

By the time we arrive at the gallery, the cameras are on and the exhibit begins. Our younger daughter, Meaghan, steps aside and finds refuge and safety beside her father, as do I. Amanda takes her place in the spotlight where she belongs. Amidst the reporters and photographers, children and adults crane their necks to view our daughter and the fresh collection of paintings she is exhibiting at this latest show. We are among those trying to catch a glimpse. It is sometimes difficult not to get caught in the shuffle as people move around to try to hear her speak. Amanda is radiant as she explains the stories and ideas behind her images. She has a sweetness that makes her approachable and the children seem to adore her. Her fair complexion and auburn hair make her easy to spot through the crowds and we can see that she is doing just fine. Only we as her parents recognize that she is a bit self-conscious about the braces on her teeth. Only we as her parents are aware of the laughter that she has shared with her sister only minutes before.

Following Amanda's television debut, we have quickly discovered just what an impact her paintings have on other people. The messages from Amanda's angels are getting out to those who need them, and the requests to purchase her work are overwhelming. At gallery exhibits, we are moved to often see people weeping as they view the paintings. At one show, we heard a woman exclaim, "That painting was meant for me! It's about my life. I can't believe she has painted my life."

As the frenzy continues to grow surrounding Amanda and her incredible gift, we are reminded daily that she is a messenger of sorts who happens to still be a child. She is still the little girl who cries when she says good-bye to one of her paintings and who delights in meeting their new owners. She cares less for pomp and more for paint. She is an old soul who lives on a higher plane than most of us will ever reach in our lifetime, and she works hard to help people see what is really important in life. She is delightfully comical yet serious at the same time. She will be an artist forever.

We are so grateful to everyone in our lives who has made it possible for Amanda to achieve her phenomenal success. A sweet memory often comes to me in my times of solitude. It is of a particular afternoon when I held Amanda as a tiny infant in my arms. She was making sweet little baby sounds with her voice as she slept. My grandmother leaned over us and whispered to me, "She's talking to the angels." The memory had always made me smile, but it does so even more today.

— Judi Dunbar
March 2000

# GUIDED BY ANGELS

# Amanda Dunbar

■ ■ ■

# FRENCH
# IMPRESSIONISM

# MOTHER'S TOUCH

24 x 30, OIL ON CANVAS, 1996

*This is the first painting I ever did. I painted it for my mom for Mother's Day. She was surprised and shocked at the same time. She says it is her favorite. It is my interpretation of her drying me off after my bath. This is a very special painting.*

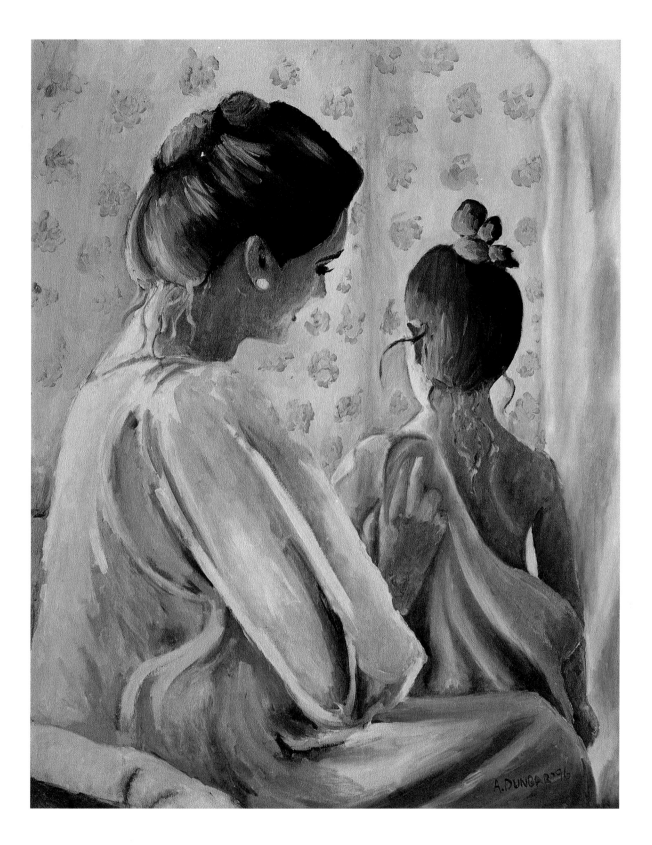

# AFTERNOON TEA

33 x 46, OIL ON CANVAS, 1996

*This is my second painting. My mother is a very important part of my life, and painting her was a way for me to communicate my love and appreciation. My mother is a great lover of tea. One of the many things she does every day is make herself a cup of hot tea and take the time to sit and think or read. It's a quiet moment that I like to join her in, because we get to talk about anything and everything. This is one of those times when I feel very close to my mother.*

■ ■ ■

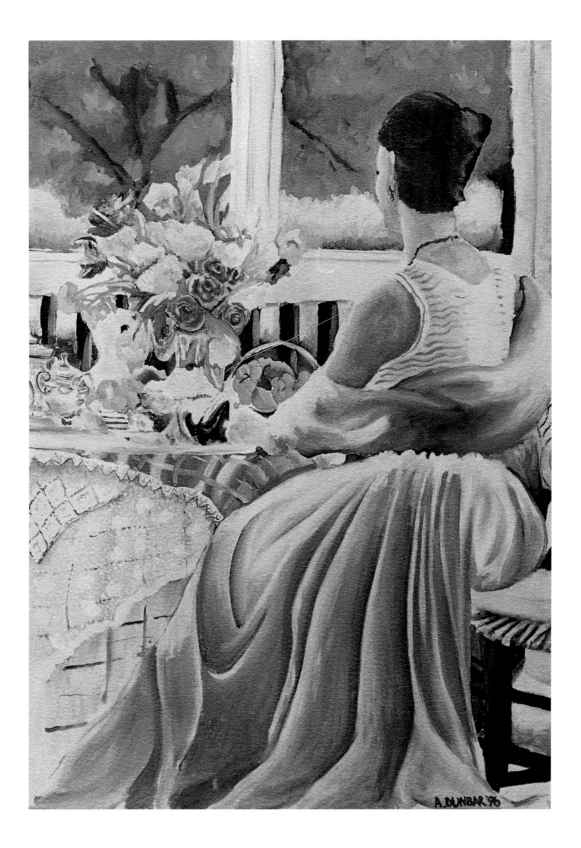

# A PIE FROM
# GRANDMA'S OVEN

24 x 36, OIL ON CANVAS, 1998

*There has always been something very fascinating to me about old-fashioned stoves. My great-grandmother had one. I love baking, too. Somehow when I reach into the oven to pull out a pie that was made from Grandma's recipe, it is like pulling out a piece of the past.*

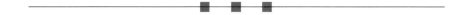

# WALK TOGETHER

36 x 48, OIL ON CANVAS, 1998

*Quiet times when I can be with those who are very impor-tant to me mean a lot. This painting captures just such a moment: being with two people very special to me, my mother and sister, in a setting where the conversation is about anything or nothing at all. Words don't have to be spoken to touch each other in these moments.*

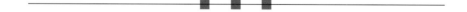

# COOKIE CHEF

24 x 36, OIL ON CANVAS, 1998

*I have loved to bake cookies for as long as I can remember. I see this girl as myself. When I was little, I would get out all of my baking stuff and Mom would let me do it "all by myself," or so I thought. I usually had to have a bath afterwards because I would have flour and cookie dough all over me. I'm a little bit neater now when I bake cookies, but not a lot.*

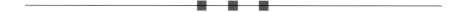

# SOLITUDE

24 x 36, OIL ON CANVAS, 1998

*Sometimes I like to leave the world behind and spend some time alone. This young girl represents quiet reflection and anonymity to me. I think we all like to go to this place just to enjoy solitude.*

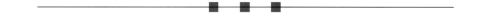

# SIMPLE BEAUTY

30 x 22, OIL ON CANVAS, 1998

*This painting portrays a young girl picking a flower. The flower sits by itself, and its simple beauty catches her eye. Each thing in nature holds its own unique loveliness. I love to look closely at growing things. To me, they all have simple beauty.*

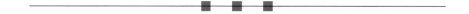

# THE ARCH

30 x 40, OIL ON CANVAS, 1998

*I don't know where this place is or the reason it wanted to be painted. The pathway is inviting and the leaves seem to beckon me through the arch. This painting is still a mystery to me. It speaks to many people differently.*

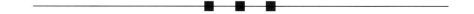

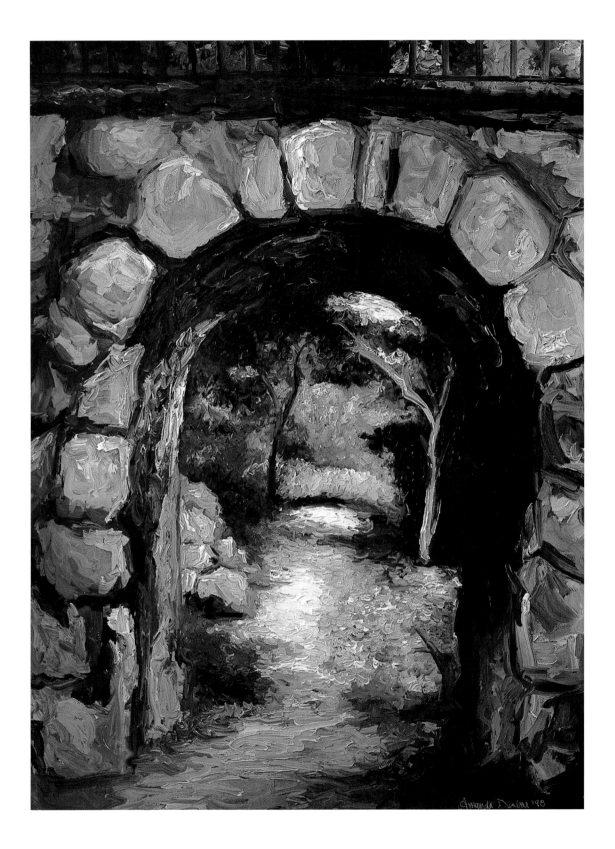

# ALL IN A DAY'S WALK

20 x 26, OIL ON CANVAS, 1998

*This painting is my way of capturing the inquisitive nature of toddlers. Every tiny rock or leaf is a source of fascination and it is just too tempting to leave them untouched. It's a toddler's work to explore everything and anything in a day's walk.*

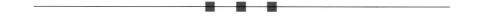

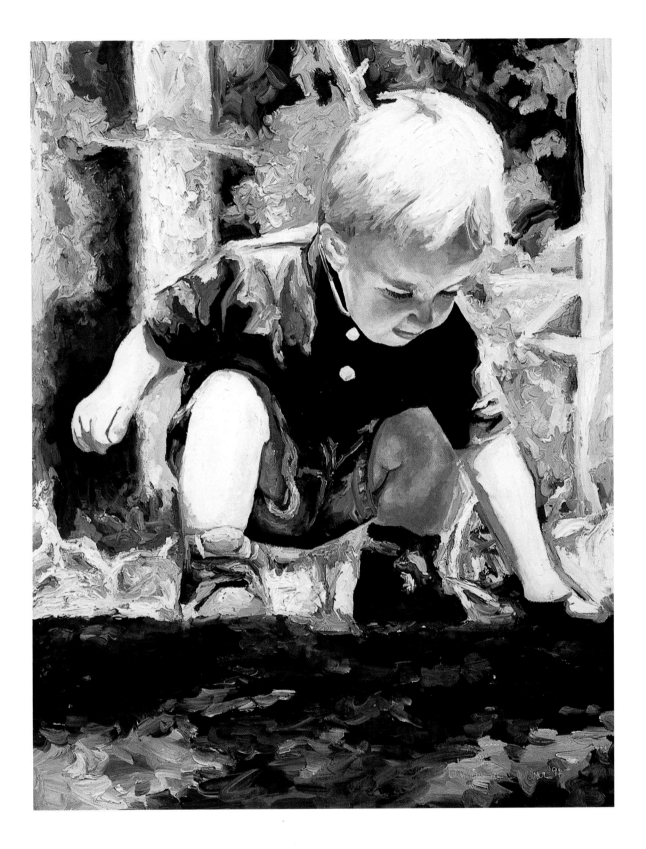

# COAST GUARDS

36 x 48, OIL ON CANVAS, 1998

*This painting was inspired by the fun my sister Meaghan and I used to have floating toys, sticks or other creations in the water. The best time was after a good rain. We would dress up in our raincoats and boots, and head for any water source we could find. Usually it was just a puddle in the driveway, but sometimes an adult would take us to play by the lake.*

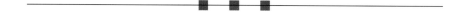

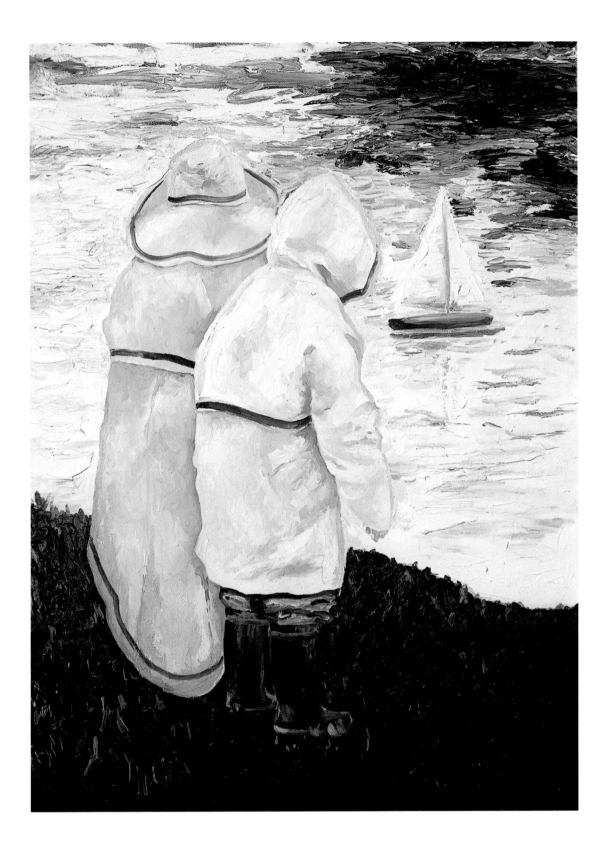

# CHRISTMAS COOKIES

40 x 30, OIL ON CANVAS, 1998

*Every year for as long as I can remember, my mom and dad baked stained glass cookies with us on Christmas Eve. These are very special. They are large sugar cookies with hard candy melted in little cutout windows. We hang them in the window with pretty Christmas ribbon. It is a tradition in our home.*

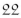

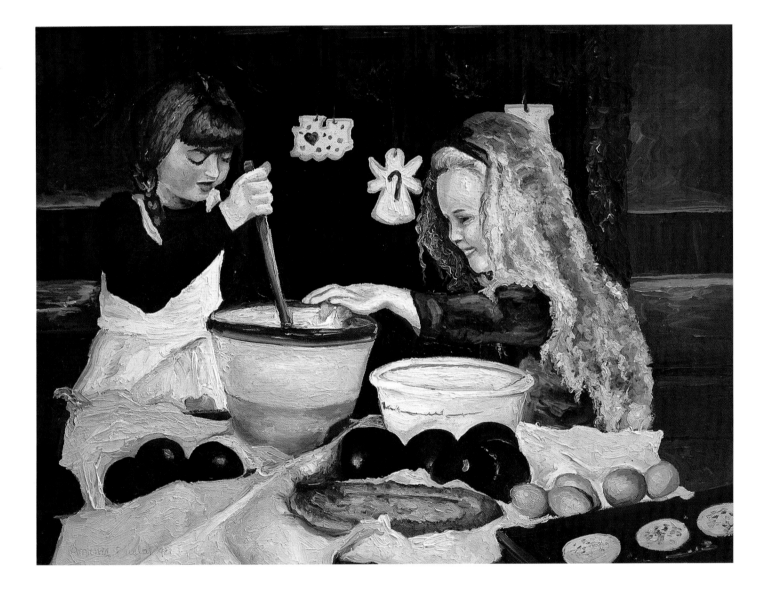

# THE UNKNOWN

30 x 40, OIL ON CANVAS, 1998

*This little girl is standing in the safety of her own yard. She is surrounded by all that is familiar to her, yet she yearns to know what is on the other side of the fence. The darkness on the other side of the fence is the unknown. It not only holds her fear, but also her future and opportunities. Many of us need to leave our comfort zone and venture into the unknown. This painting represents a triumph of spirit.*

■ ■ ■

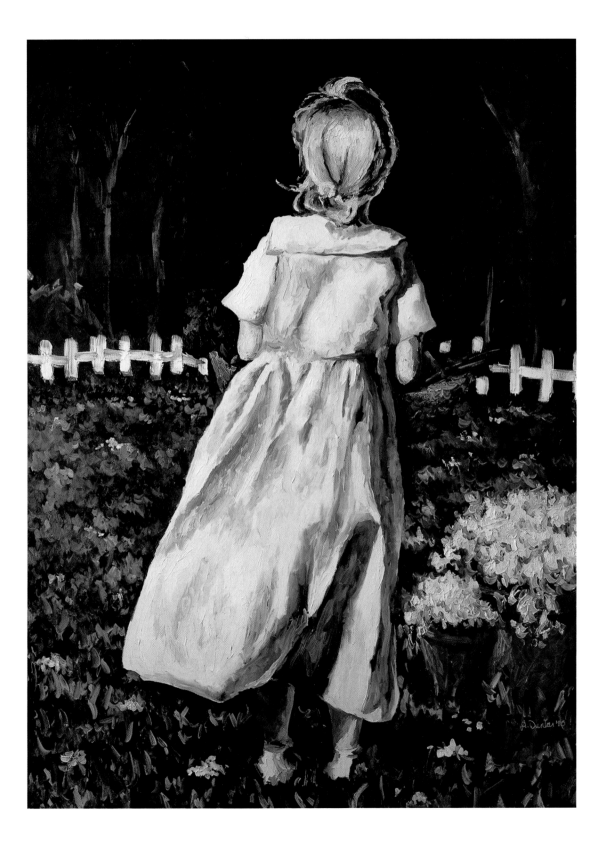

# COMFORT

36 x 48, OIL ON CANVAS, 1999

*The unknown is still in the distance, beyond the fence. I want to show that we don't need to face the unknown things in our lives alone; we can turn to those who are closest to us for support. This painting represents the support of a mother who is comforting her little girl, helping her to challenge herself and ultimately to conquer the unknown.*

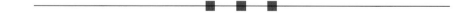

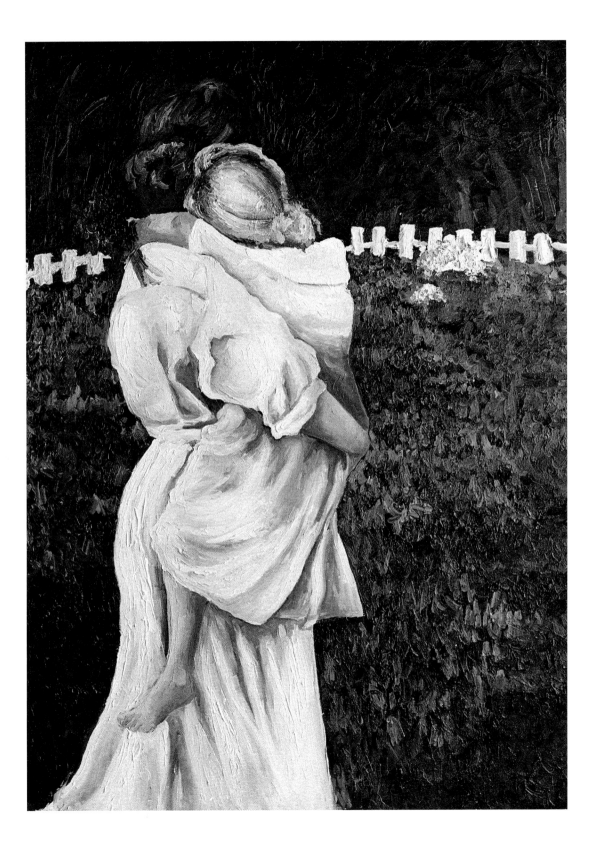

# A GENTLE
# FASCINATION

20 x 26, OIL ON CANVAS, 1998

*This little girl is completely enraptured by the tiny life she holds in her hands. And the little duckling is equally curious about her. They are studying each other in gentle fascination.*

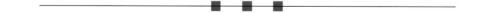

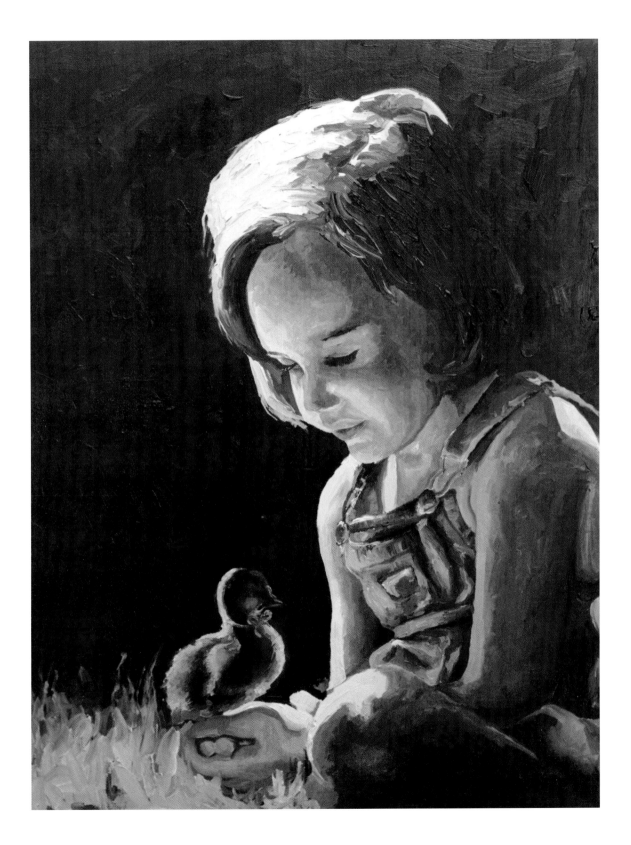

# LILAC LADIES

30 x 40, OIL ON CANVAS, 1998

*In Canada when my sister and I were little, we had wonderful lilac trees in our yard. Meaghan and I would pick them and spend hours putting them in each other's hair, making bouquets for Mom and just smelling them. They always smelled so wonderful. These little girls represent Meaghan and me.*

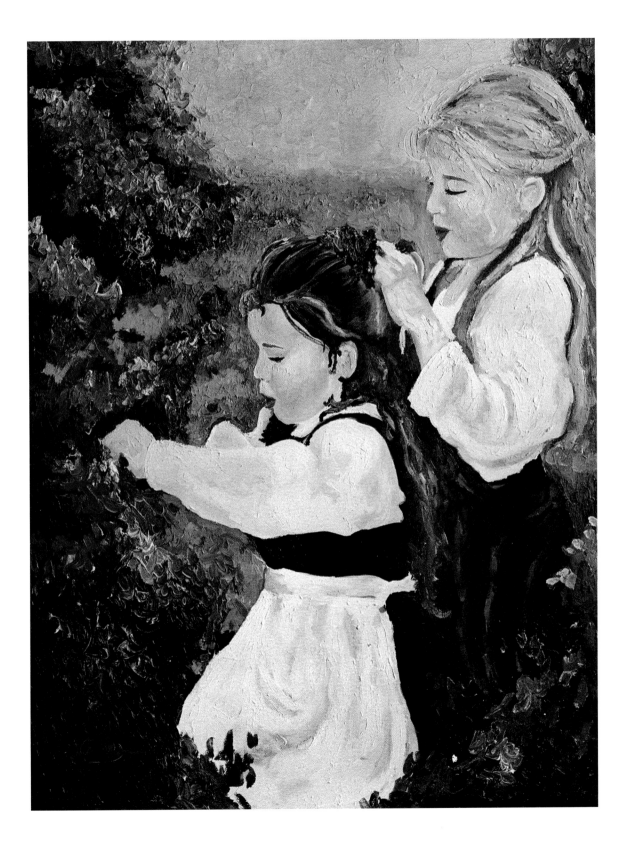

# BLUE BONNETS

36 x 24, OIL ON CANVAS, 2000

Since moving to Texas, I have been introduced to blue bonnets. They are absolutely beautiful flowers and I love them. It's hard to believe that nature can make such incredible shades of blue and then melt them all together in field after field.

# SILVER SANDS

24 x 36, OIL ON CANVAS, 1998

*I love the look and feel of the silver white sands on the beach. It feels wonderful and soft to walk in the sand, and I like the way it sifts between my toes. If I close my eyes and imagine, I can almost feel that sensation anytime . . . even in winter.*

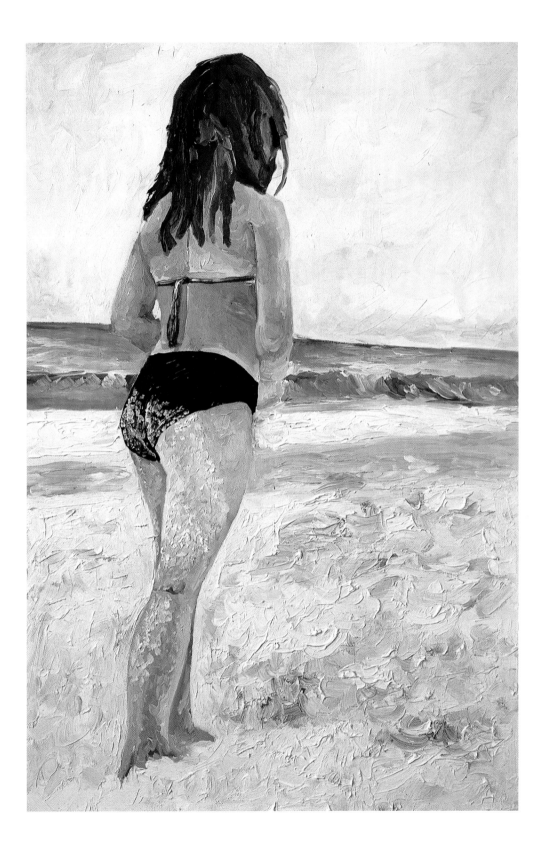

# SEA TREASURES

18 x 24, OIL ON CANVAS, 1998

*This painting depicts a little girl on the beach discovering seashells. I love finding seashells on the beach, too. There is just something about finding nature's little gifts.*

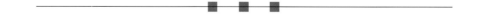

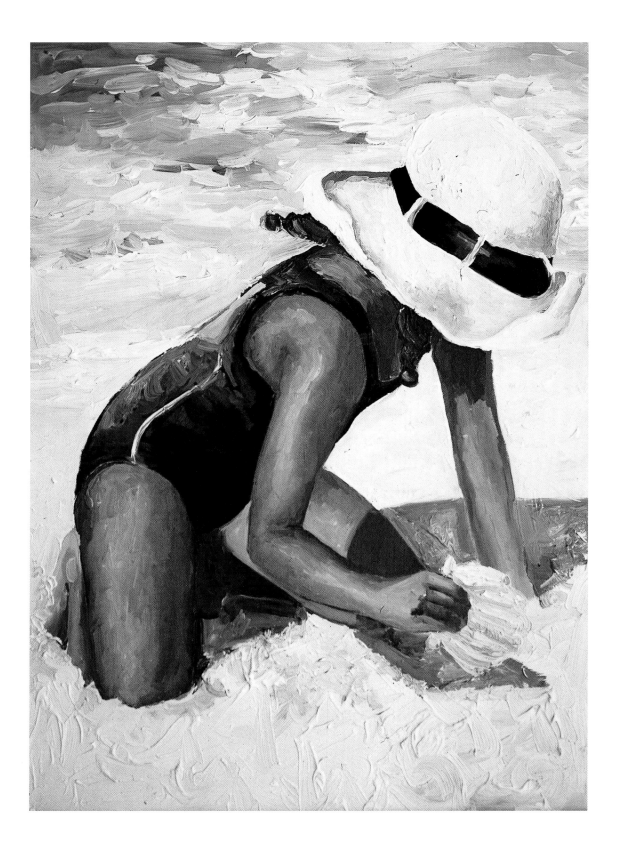

# TREASURE HUNT

30 x 40, OIL ON CANVAS, 1999

*My sister Meaghan and I spent many an afternoon looking for treasures in the water while visiting with Grandma and Grandpa at the lake. This was always fun and interesting.*

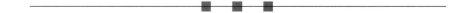

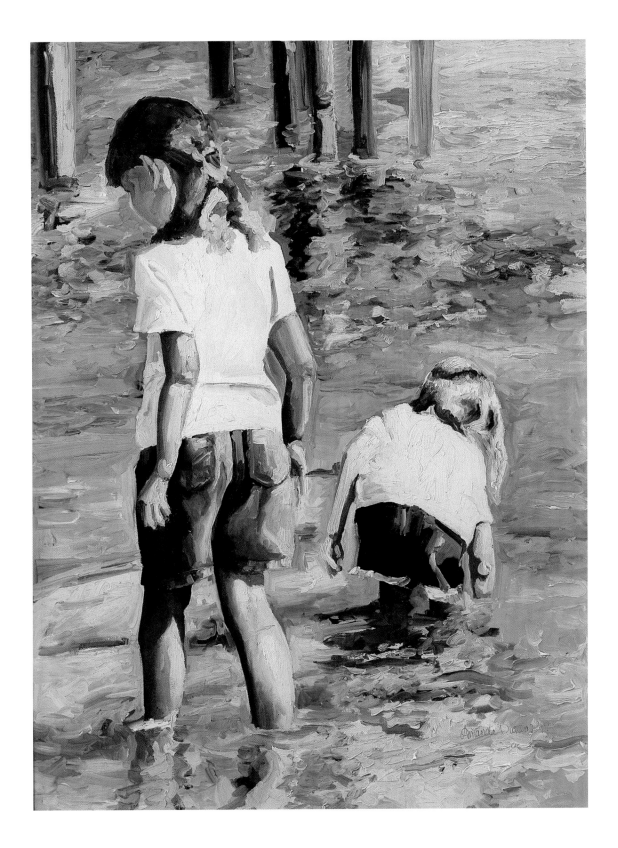

# LOOK WHAT I FOUND!

30 x 40, OIL ON CANVAS, 1999

*This painting, like* Treasure Hunt, *is about my sister Meaghan and me searching for treasures in the lake by Grandma and Grandpa's place. We loved finding neat creatures, shells and rocks.*

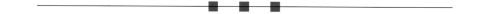

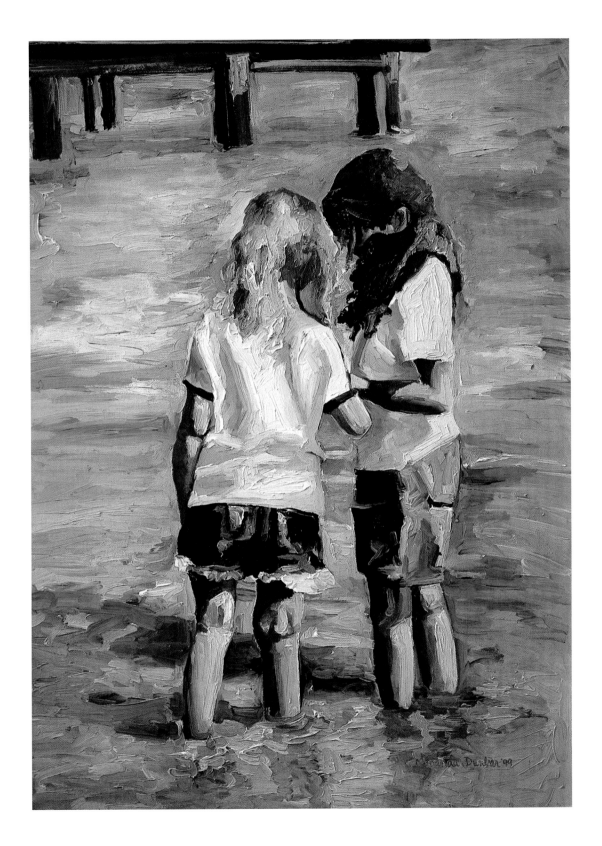

# SUMMER BREEZE

48 x 60, OIL ON CANVAS, 2000

The challenges of life are always with us day to day. We always have to face an unknown. I started a second trilogy of paintings about the unknown, depicting older girls, since I myself am growing up. The girls are closer to the fence, and able to see a little more of what is on the other side. It's no longer completely dark. These paintings continue their subjects' discovery of the unknown and their ability to conquer fear. The girls are looking toward their future and at the beauty that is yet to come.

■ ■ ■

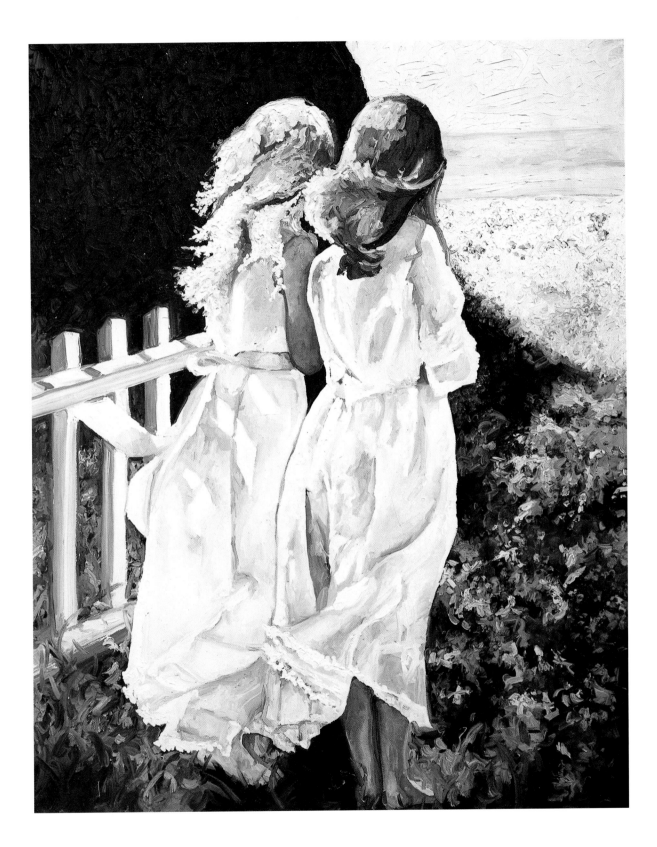

# OCEAN VIEW

48 x 60, OIL ON CANVAS, 2000

There comes a time in everyone's life when you influence the life of someone else. We may not even be aware of it when we're doing it. This painting depicts two young girls exploring their unknown. They are beside the fence, which represents a safe boundary. The older child is showing the younger child how beautiful and exciting the unknown is. Instead of being ominous, as in the first trilogy, the unknown here is open and beautiful.

■ ■ ■

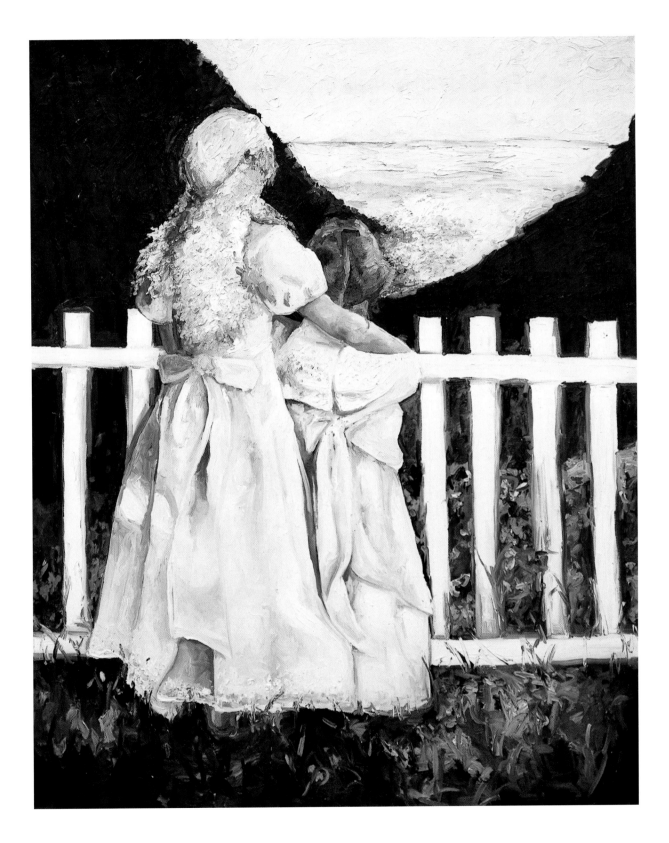

# Amanda Dunbar

## AMERICAN
## EXRESSIONISM

# GREAT-GRANDMA'S HOUSE

30 x 24, OIL ON CANVAS, 1997

*I found a picture of my great-grandmother's home in the back of my dad's desk. For some reason, I had to paint it. My mother has not seen this place for many years, even though she practically grew up there. This painting made her cry. It means a lot to her.*

# TUB TIME

30 x 40, OIL ON CANVAS, 1998

*Sometimes the best playthings are the simplest. On a hot summer's day, an old metal washtub was just as much fun to play in as any swimming pool. This little boy is enjoying his own little water world.*

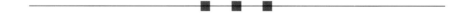

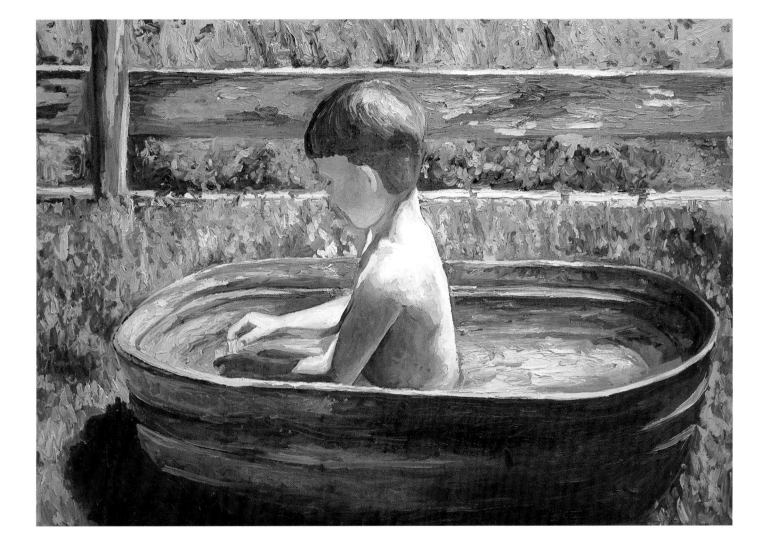

# JUST MY SIZE

30 x 40, OIL ON CANVAS, 1998

This painting is so much more than a little boy trying on his father's hat. This boy symbolizes our future, the child who will one day fill his father's shoes (or in this case, his hat). I don't think enough people take the time to think about how important children are and how they are so affected by adults and the world around them. A smile can totally change their mood and a kind word can mend sad feelings. We all need to learn to be better role models and better people for the children.

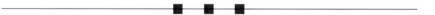

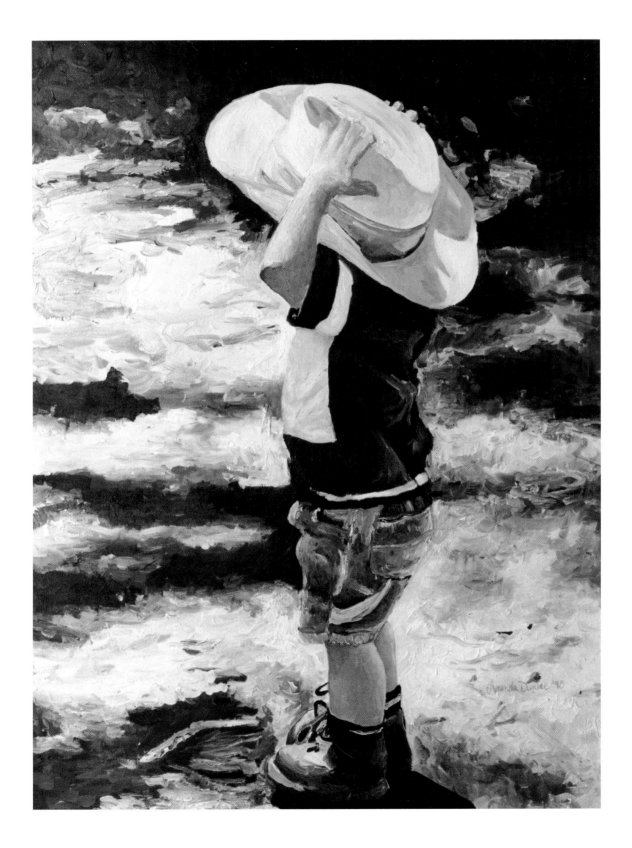

# A JOURNEY IN BROTHERHOOD

36 x 48, OIL ON CANVAS, 1999

*These two little boys portray the essence of understanding. They are reading and learning together. This is the basis for all of us. Reading builds knowledge and knowledge builds understanding. Understanding ultimately promotes tolerance and a kinder world.*

■ ■ ■

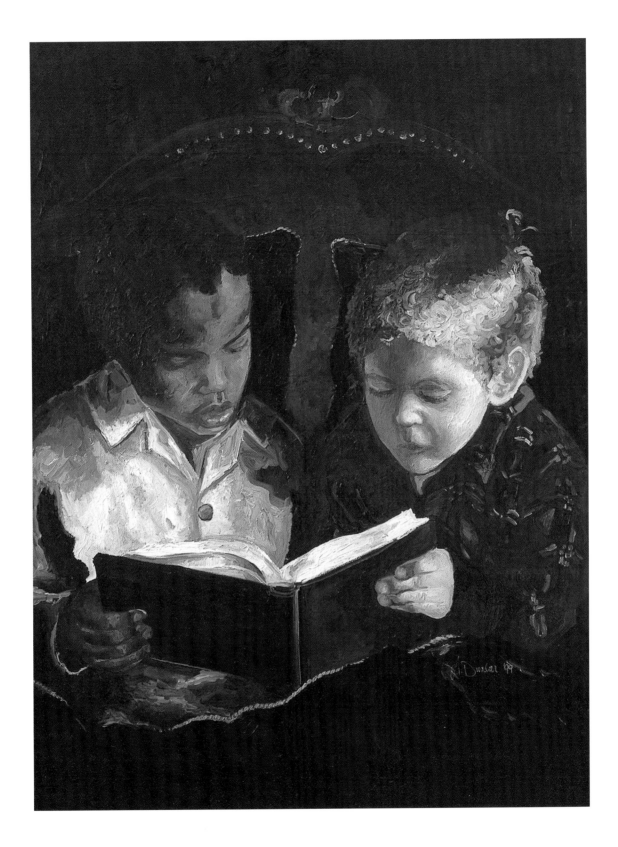

# HELPING DAD

28 x 22, OIL ON CANVAS, 1998

*This painting is my interpretation of a little boy whose family is good friends with ours. He has always been inquisitive and "helpful." In fact he loves to "help" with everything, especially if it's with his daddy. He is special to me.*

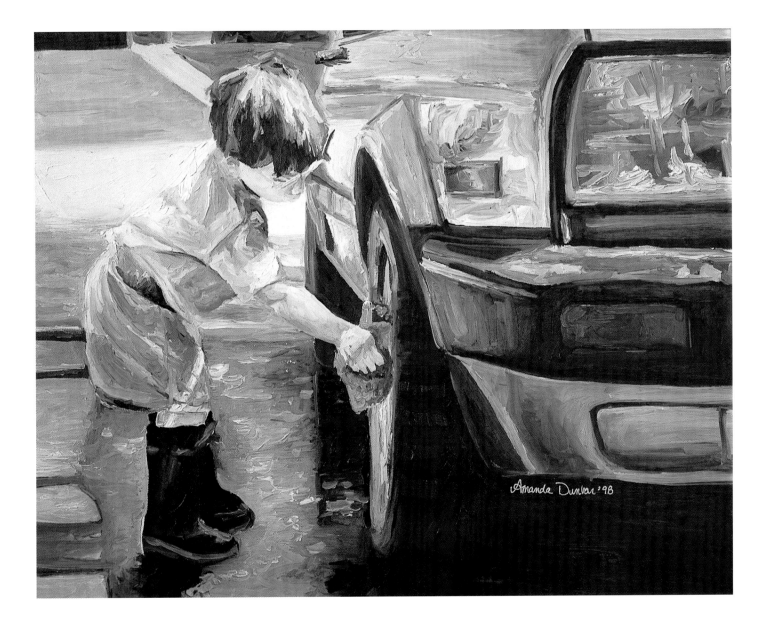

# MY NEW GREEN TOOTHBRUSH

18 x 24, OIL ON CANVAS, 1999

*When I was little I used to love going to the dentist. He would always let me pick out a new toothbrush of whatever color I wanted. I always wanted to rush home and try it out. This little girl is trying out her new green toothbrush. This painting portrays the simplest of childhood pleasures.*

■ ■ ■

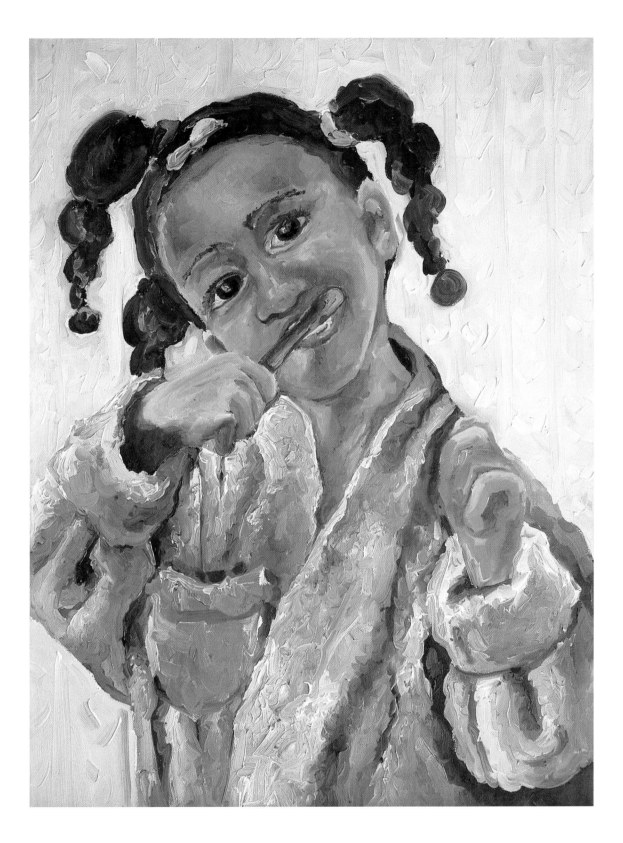

# THE SPRINKLER

24 x 30, OIL ON CANVAS, 1999

*There is something about a sprinkler in the summertime that makes me want to jump through it. My dad would let us get our swimsuits on and run through the water as it shot out of the sprinkler. It was cool and delightful as it cascaded down around me.*

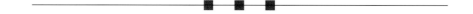

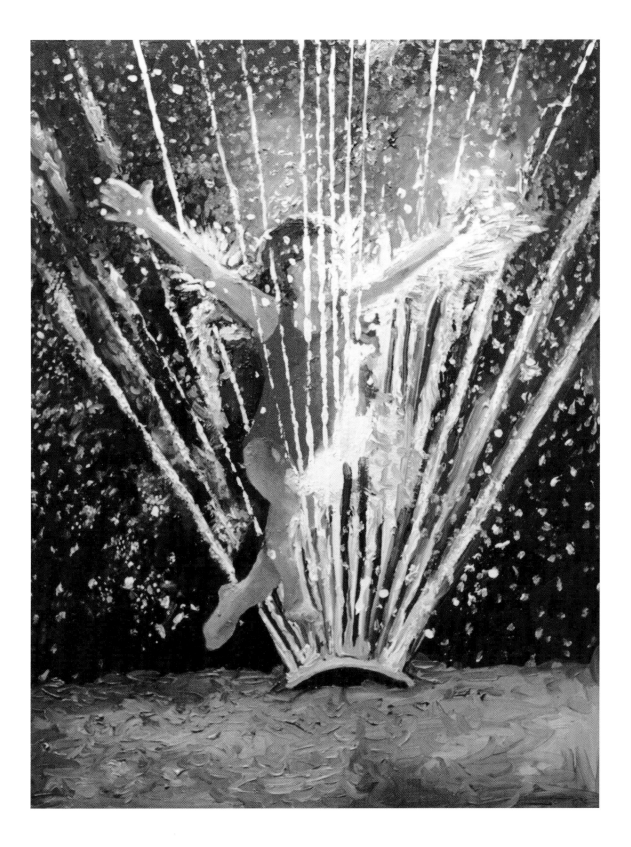

# FLY AWAY FREE

30 x 40, OIL ON CANVAS, 1998

*My sister and I have always loved butterflies. Not only are they beautiful and free, but they have had to go through a long transformation to become that delicate creature. Butterflies have always represented to me the wonderful freedom that comes after hard work and sacrifice.*

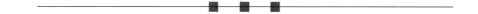

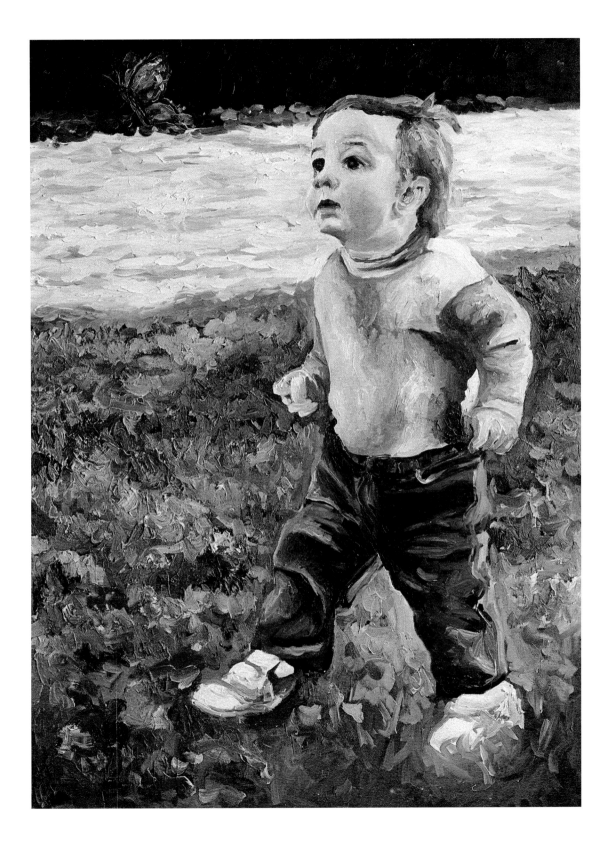

# LADY BUG, LADY BUG, FLY AWAY

36 x 48, OIL ON CANVAS, 1998

*This little boy sees the ladybug sitting on the leaf. He wants to touch it but he's undoubtedly been told "Don't touch." I think he must be remembering the old nursery rhyme "Lady bug, lady bug, fly away home."*

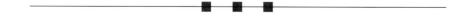

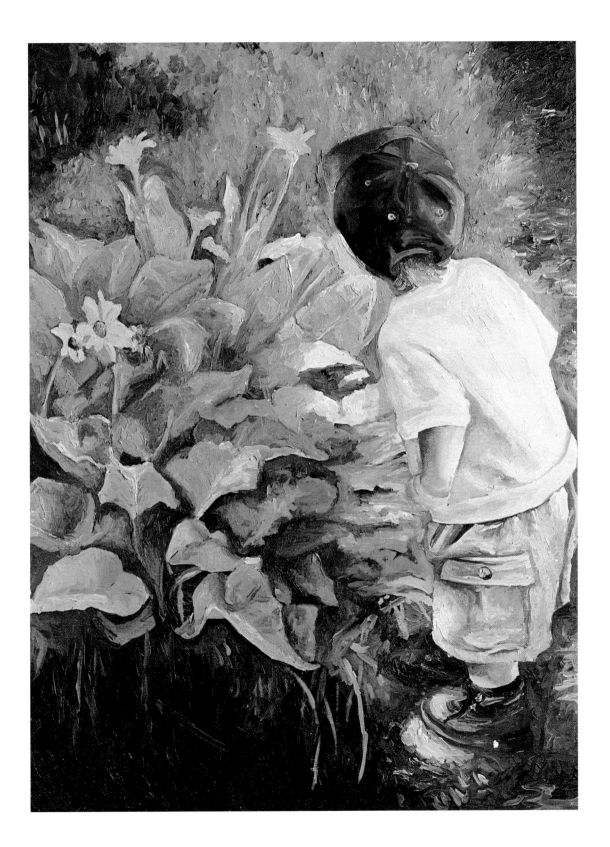

# FOREVER YOUNG

30 x 22, OIL ON CANVAS, 1999

This painting depicts my great-grandfather and his spirit that never ages. He always has a mischievous twinkle in his eye and a smile that welcomes all children. He is a gentle person who respects nature and loves being surrounded by children. Great-grandpa is a wonderful teacher and I love him. This painting is a depiction of the man I know and adore who truly has never grown old.

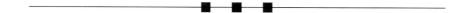

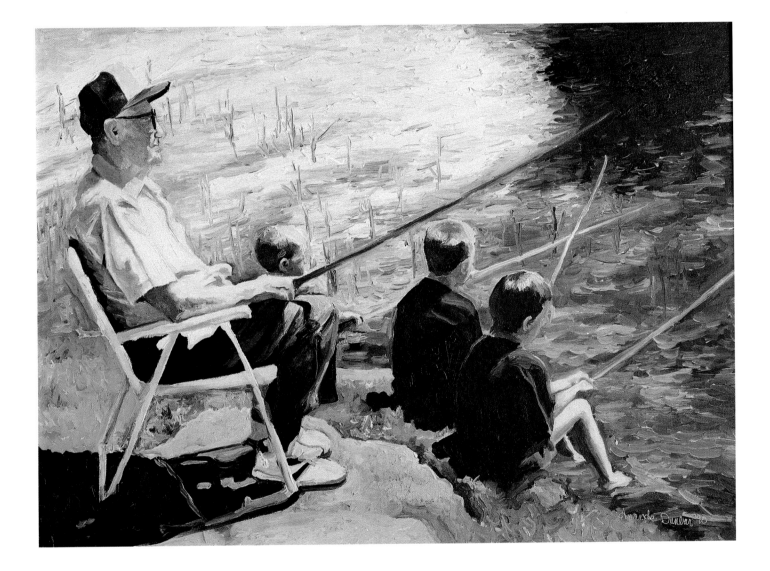

# ME AND MY SHADOW

30 x 40, OIL ON CANVAS, 1998

*This is another painting about me when I was little. I used to love to dress up in my party dresses, although I didn't like shoes very much. I would put on my dress-up beads and pretend I was a princess. I would take my favorite green blanket everywhere I went. My mom made it for me when I was a baby. It has been my shadow for many years. I still have it and all the memories it carries.*

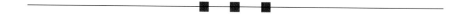

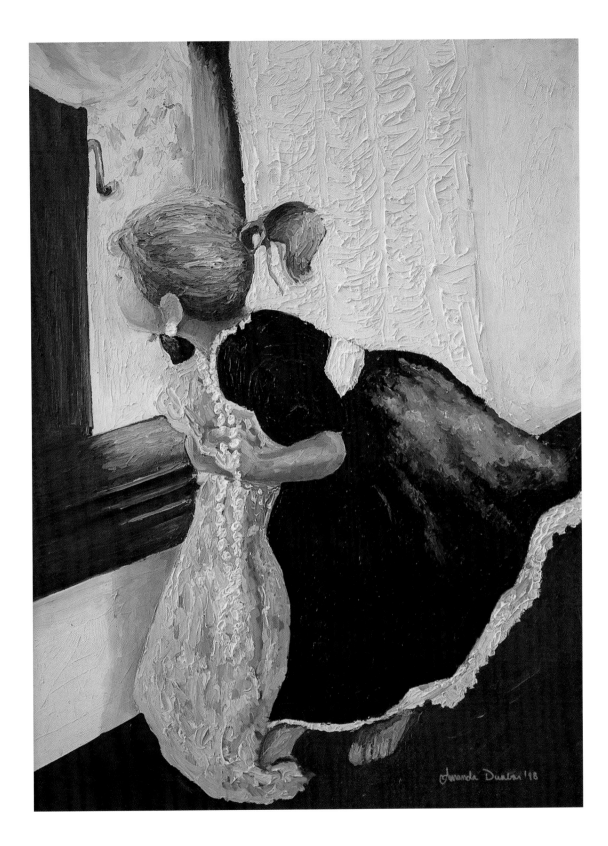

# THANK YOU, DADDY

60 x 48, OIL ON CANVAS, 1999

*Little creatures can be a big part of a family. This little boy's dream of a puppy has just come true. Caring is passed along from the daddy to the son, and from the son to the puppy. It also is passed back along the same path. I think passing love from one to another and returning it is the key to happiness.*

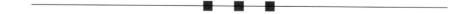

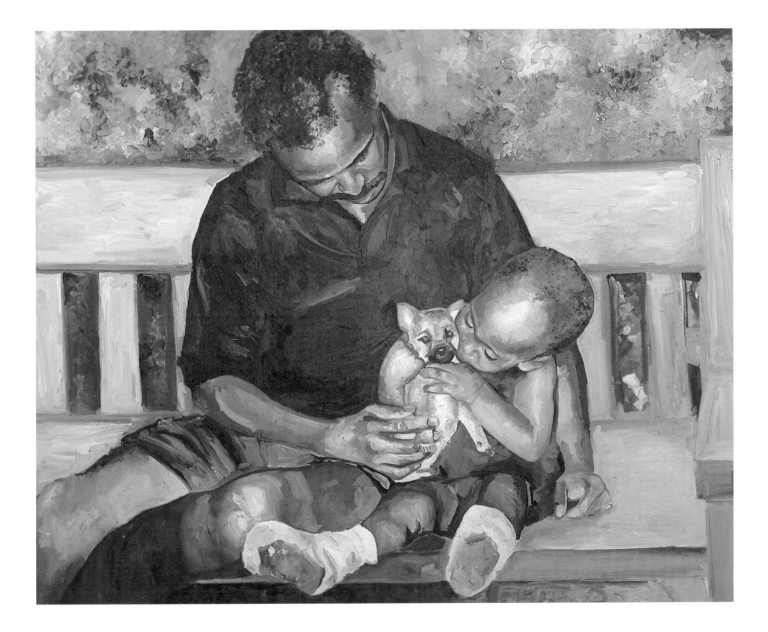

# TEST THE WATERS

24 x 30, OIL ON CANVAS, 2000

*This painting represents my sister, Meaghan. No matter where we were, if there was a puddle in sight, Meaghan had to see how deep it was. When we were little my parents always bought us rubber boots so we could "test the waters."*

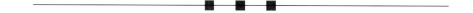

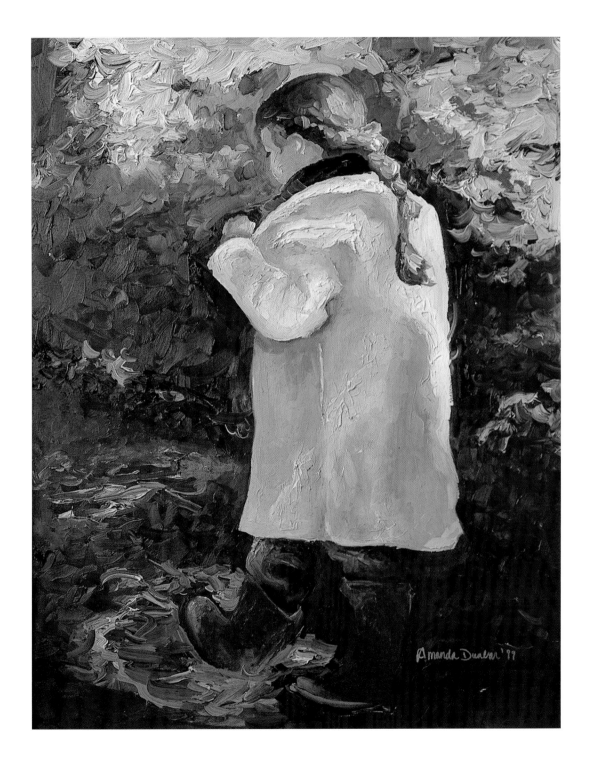

# LET IT SNOW, LET IT SNOW

36 x 48, OIL ON CANVAS, 2000

*I can remember many times as a child in Canada watching the first snow fall to the ground. It was very exciting because we knew that as soon as the grass was covered, there would be enough snow to start building snowmen and making snow-angels. Meaghan and I would beg to go outside to play in it almost as soon as the snow began to fall! It was wondrous.*

■  ■  ■

# SELF

36 x 48, OIL ON CANVAS, 2000

*This painting is a depiction of me when I was small. I had a very special backpack that I took with me every-where. I loved being creative, even though I wasn't all that good at it. I've never really worried about whether or not my creations were good—I just loved the process because it was liberating and fun. My beautiful creations always found their way to the place of honor in our home: the refrigerator!*

■ ■ ■

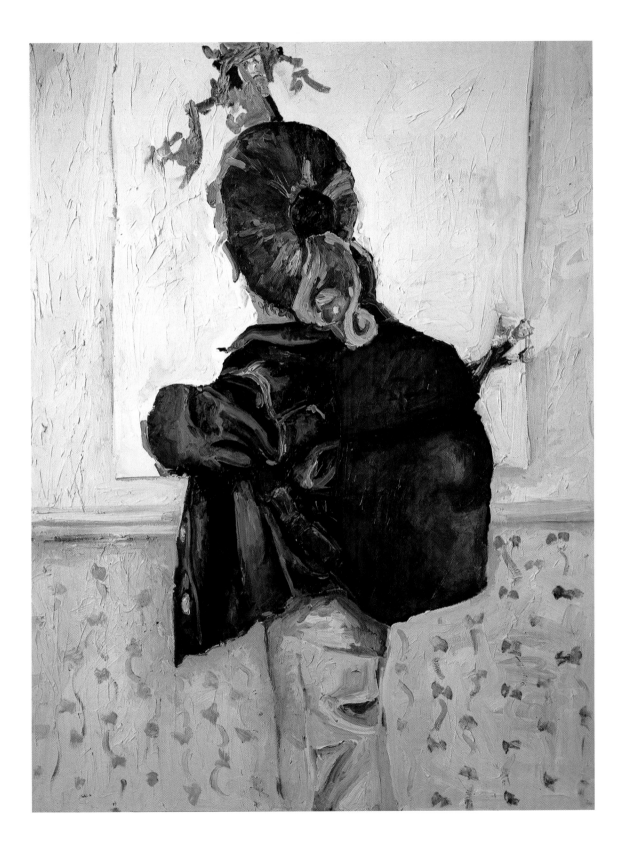

# THE BAKER

36 x 48, OIL ON CANVAS, 2000

*Next to painting, I love to bake. Some of my happiest childhood memories are of making something sweet and good out of ingredients that by themselves were not very tasty. I was always amazed that something as bitter as cocoa, molasses or vanilla could make a cake or cookies taste so good. Of course I had to taste all the ingredients individually when no one was looking.*

■ ■ ■

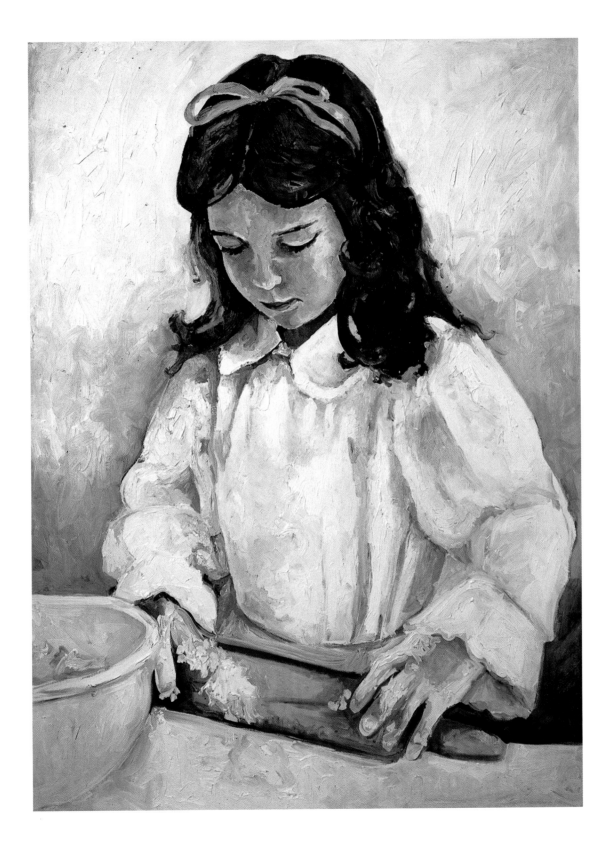

# Amanda Dunbar

■ ■ ■

## ABSTRACT

# MANDI'S STUDIO 2

48 x 60, OIL ON CANVAS, 1999

I love this painting! It is about my favorite place in the world. I am in my own world when I'm in my studio. This painting contains all of my favorite things: my shoes that I paint in, my palette, my favorite hot chocolate cup that I got for Christmas two years ago, my paints, my brushes and even my old paint shirt. I started this piece while I was struggling with calculus at school. That's why it is done in squares and named Mandi's Studio 2. I actually started it as a study in black and white but, as you can see, the colors just had to be. This painting is the essence of me.

82

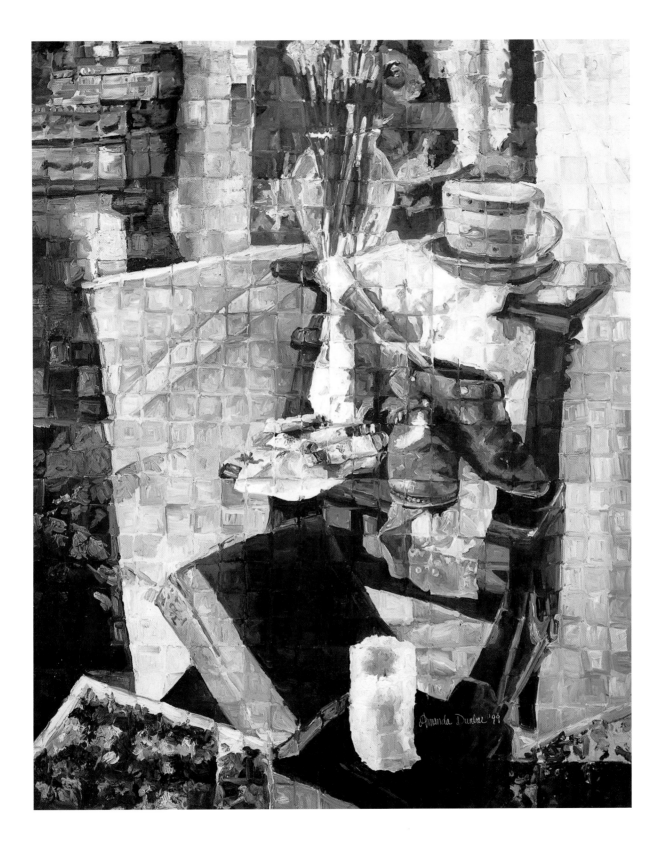

# BUBBLE MAKER

22 x 28, OIL ON CANVAS, 1999

*This painting is very special to me. It is about someone who isn't afraid to dream or to believe that wishes can come true. It's also about people who stop to have fun in life and don't let the day-in and day-out monotony consume their entire lives.*

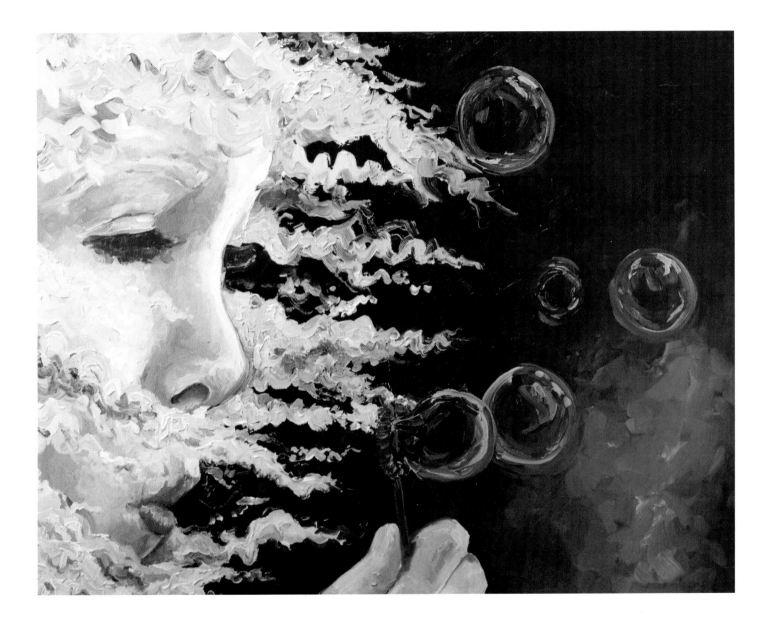

# ROMEO AND JULIET

36 x 48, OIL ON CANVAS, 1999

*For me, Romeo and Juliet's love for each other is the greatest example of love between a man and woman ever. I used sharply contrasting colors in the faces of Romeo and Juliet to represent the contrasting families and, if you look closely, you can see that they form a heart. The colors surrounding them represent the chaos in their lives as well as the passion. I created this painting based on Tchaikovsky's* Romeo and Juliet.

■ ■ ■

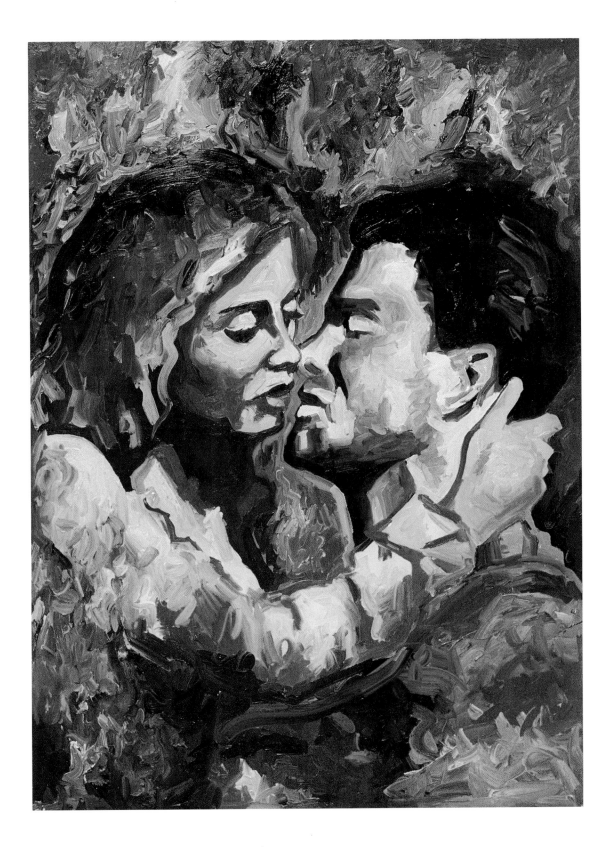

# THE GIVER OF LIFE

36 x 48, OIL ON CANVAS, 1999

*A woman is the ultimate giver of life. She carries her child inside her and loves it even though she's never seen it. It is one of the greatest displays of love, in my opinion.*

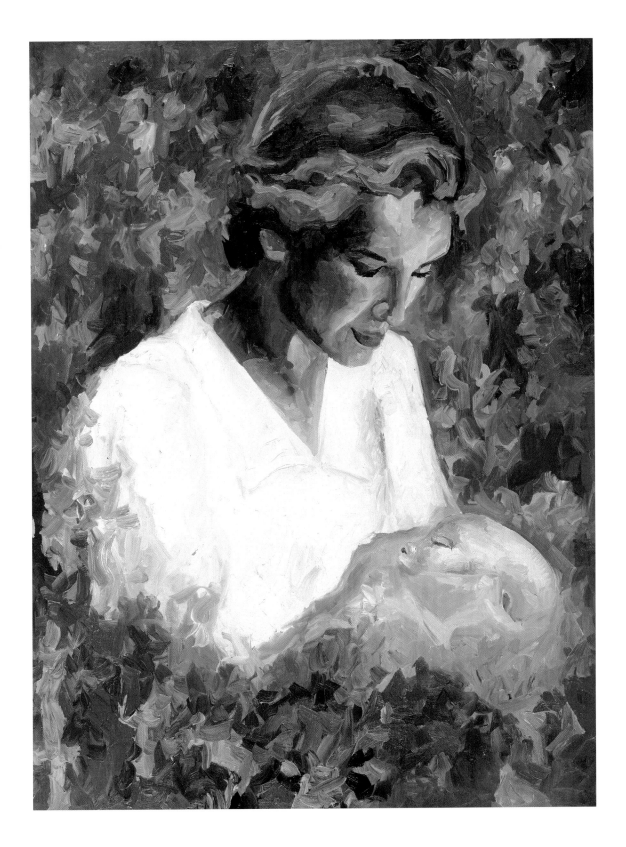

# A HIGHER POWER

36 x 48, OIL ON CANVAS, 1999

*I believe that we are all connected on a spiritual level through our souls. We are guided certainly by a "higher power." This painting portrays a man looking up toward fragments. In the fragments he sees pieces of himself and his soul — they are all around him. He is learning of the power of universal connection.*

■ ■ ■

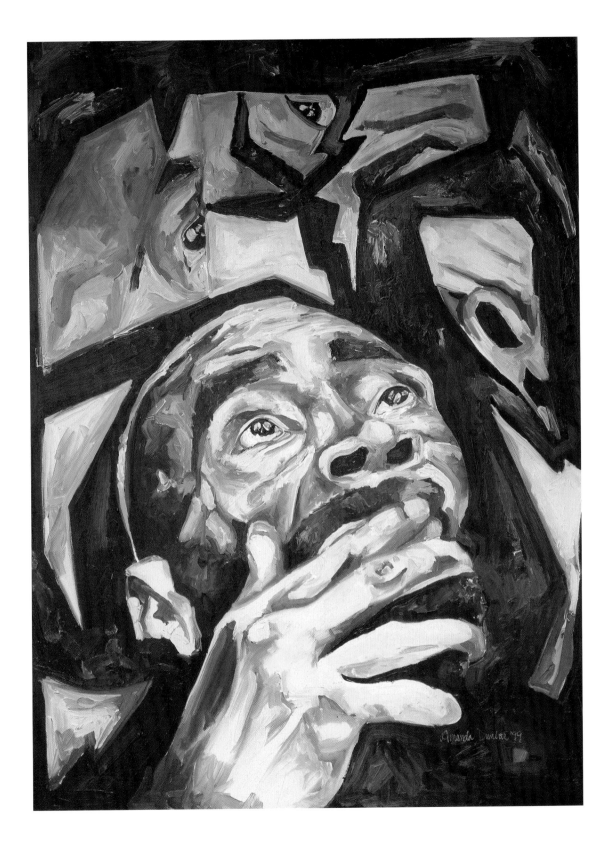

# MEDITATION

36 x 48, OIL ON CANVAS, 1999

*This painting depicts the warm, quiet, rejuvenating place I go to in my mind. It is a place that is peaceful, beautiful and mine alone. I think everyone has this place where they can go to connect with their inner spirit. There is some sort of connection between the body and the soul, and it starts in the mind. This painting depicts times when that connection is clear.*

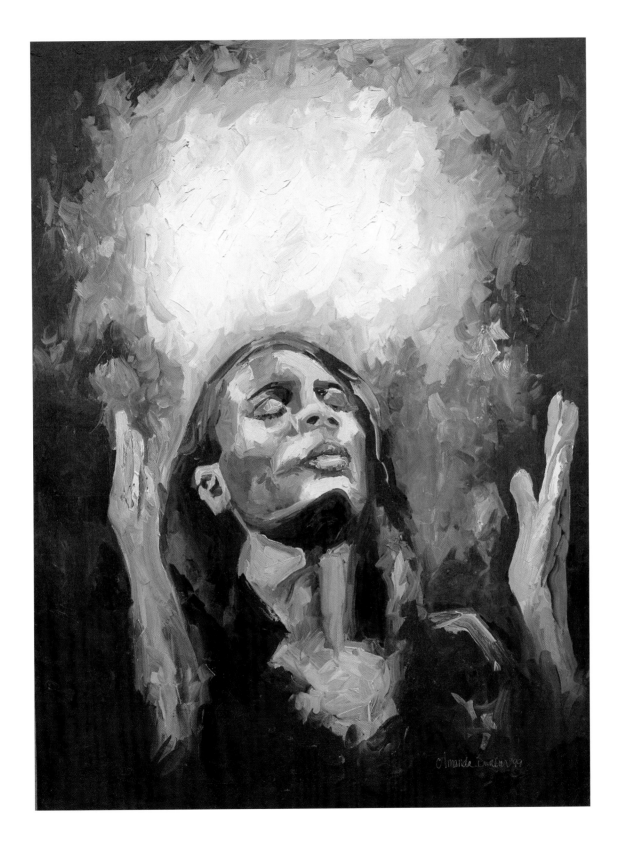

# RELAXATION

48 x 36, OIL ON CANVAS, 1999

*Warm baths before or after a hard day help everyone to soothe their busy minds. It helps bring my thoughts back to the simple things that make me content. This painting continues my exploration of the connection between the body and soul.*

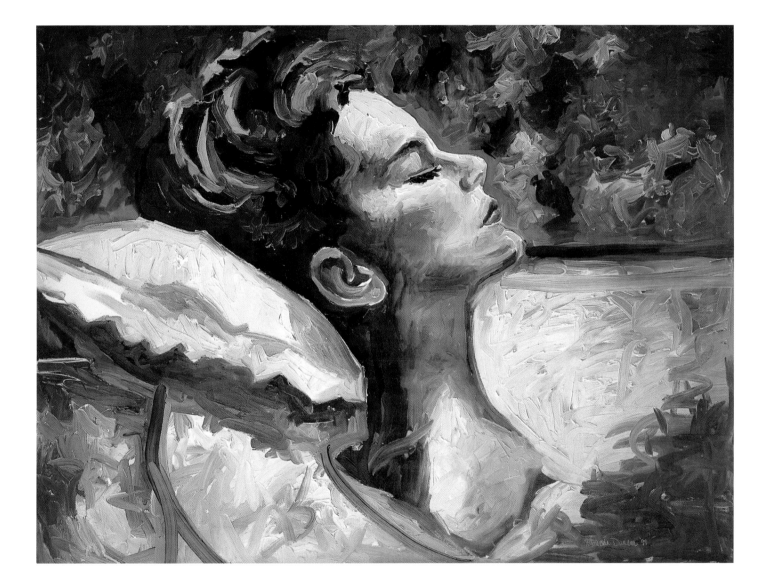

# IN MY OWN IMAGE

36 x 48, OIL ON CANVAS, 1999

*A father viewing his newborn son for the first time has many hopes, dreams and wishes for him. It will change him forever. A father's love is a powerful love.*

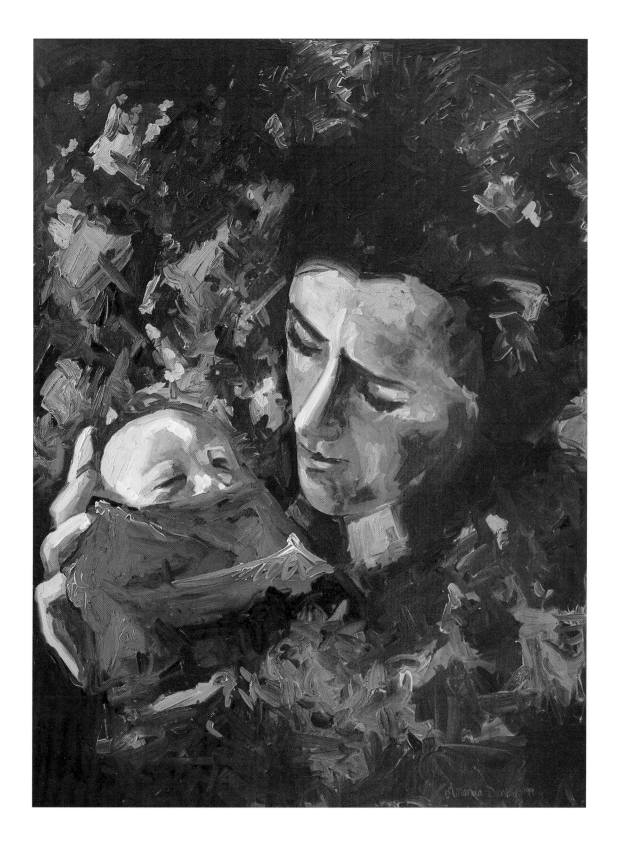

# CHARLOTTE

36 x 48, OIL ON CANVAS, 1999

*When I was waiting in the Green Room at* The Oprah Winfrey Show *last fall, I met an amazing young soprano opera singer by the name of Charlotte Church. We became friends. I think she has the voice of an angel, and it inspires me. It seems like her angels speak to mine somehow. I adore Charlotte. She's a special person.*

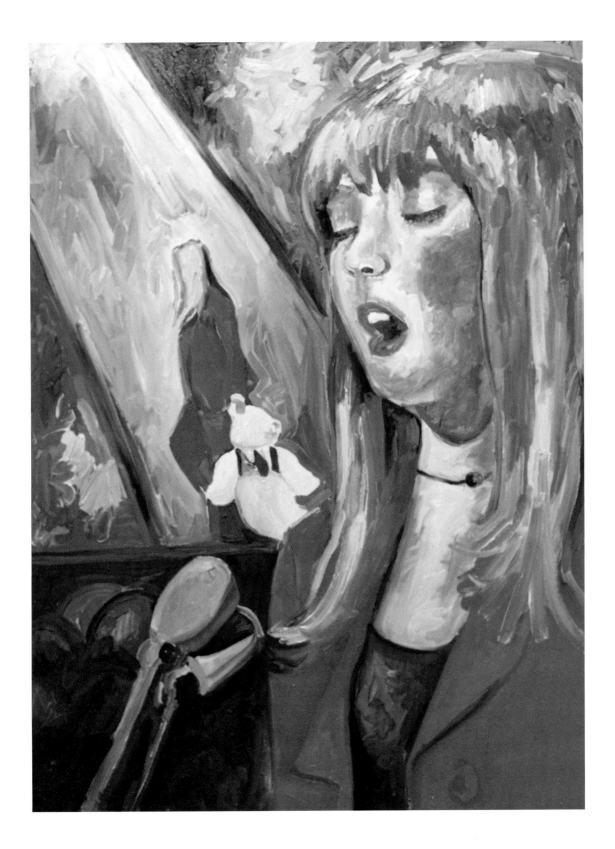

# NIGHT CITYSCAPE

24 x 36, OIL ON CANVAS, 1999

*Upon flying into cities at night, I have had the opportunity to see wonderful lights and buildings. The view often looks like pretty abstract paintings. This is one of my interpretations of the colors and shapes at night.*

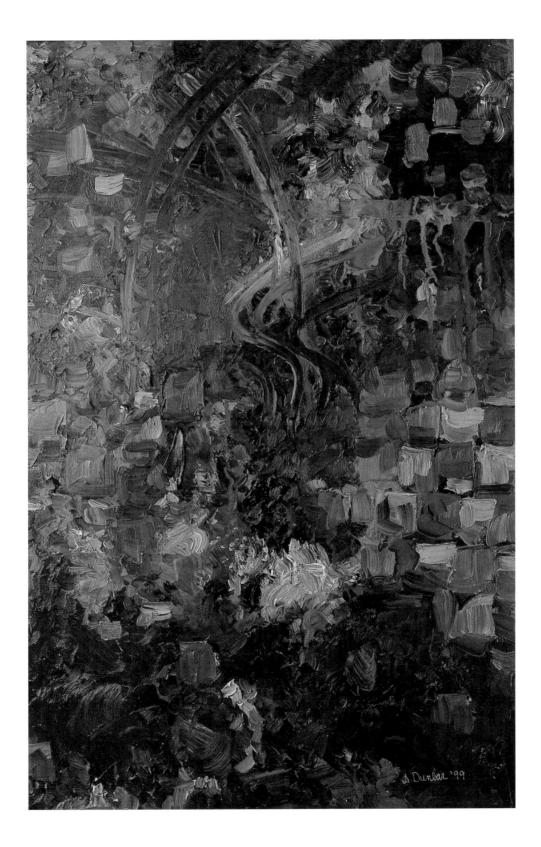

# BLAZE OF GLORY

18 x 24, OIL ON CANVAS, 1999

*I love color and how it makes me feel. This explosion of color and activity makes me happy and energetic. It is truly glorious!*

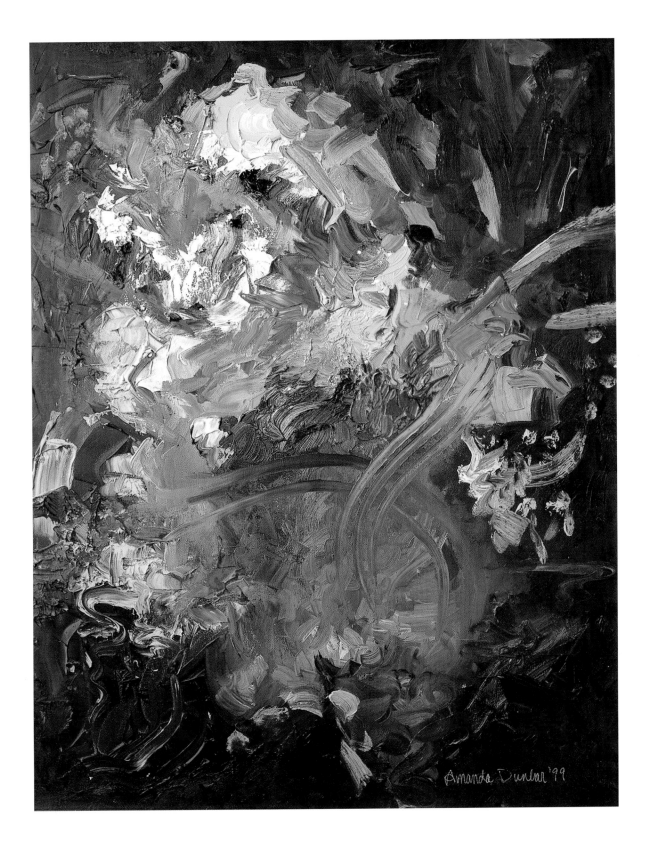

Amanda Dunbar '99

# INSPIRED I

24 x 30, MIXED MEDIA, 1999

*My sister Meaghan is a wonderful musician. I am always surrounded by music, especially when I paint. I can't play an instrument, but I feel and see music. This music series was my way of giving tribute to my sister. I have incorporated some of her original compositions into the paintings. I can't play her music, so I will paint it.*

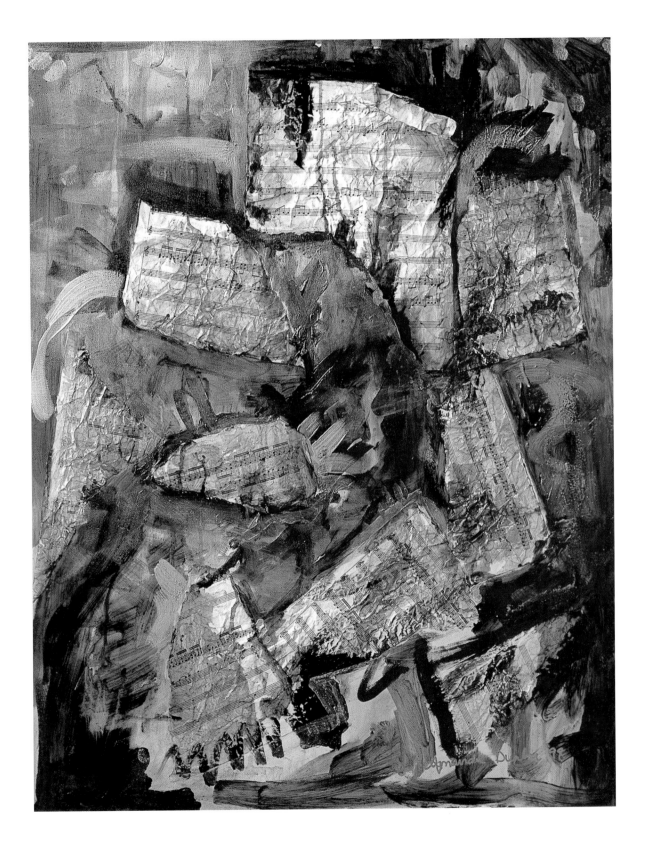

# GOLD MUSIC 1 OF 2

36 x 48, MIXED MEDIA, 1999

*These music paintings are based on my sister's musical compositions. They are beautiful and soft, much like the color gold, and I feel Meaghan's music is truly golden. These paintings are part of my tribute to my sister.*

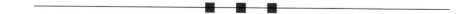

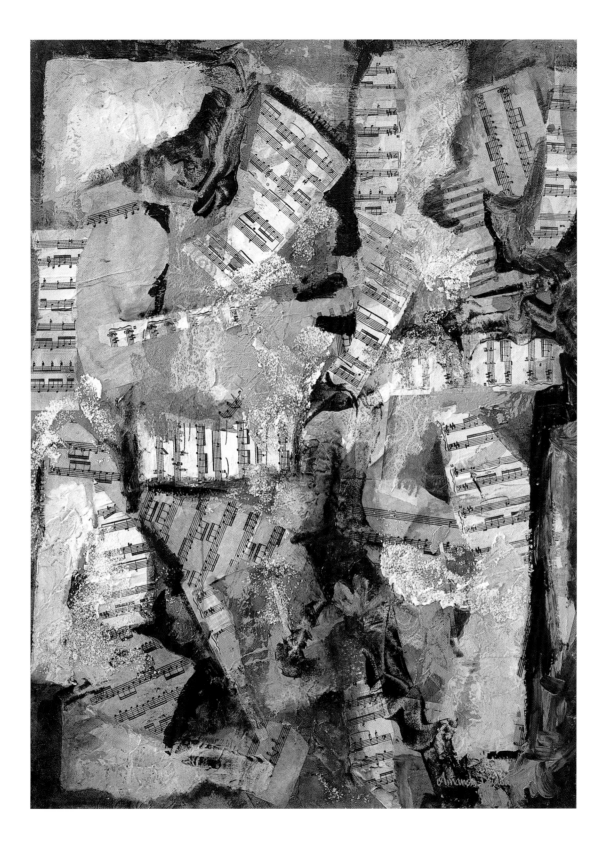

# BLUE MUSIC 3 OF 3

20 x 24, MIXED MEDIA, 1999

*The blue music paintings are yet another tribute to Meaghan's music. She inspires me and I admire her ability to play so many different instruments so beautifully. I love these shades of blue, and I used sheets of her music to paint her sounds.*

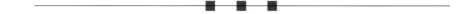

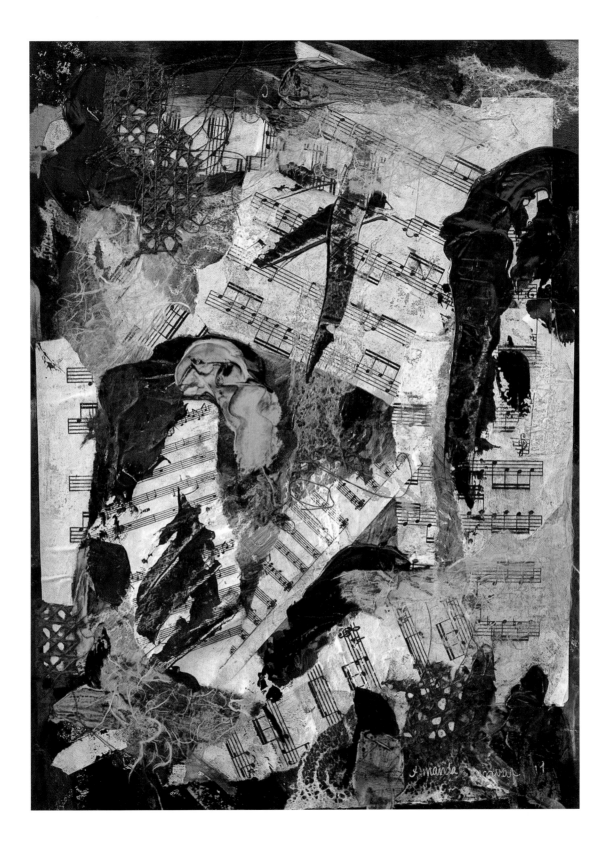

# THE TEXTURE OF
# MUSIC 4 OF 6

16 x 20, MIXED MEDIA, 1999

*This music series is my tribute to all my friends and family who make beautiful music. Everyone in my family plays an instrument or sings. My sister has composed the sheet music on many of my pieces. My friend Charlotte Church sings so beautifully that I did a painting just for her. I do not play an instrument so I have interpreted the different types of music I listen to through different mediums on the canvas. Painting is my way to make visual "music."*

■ ■ ■

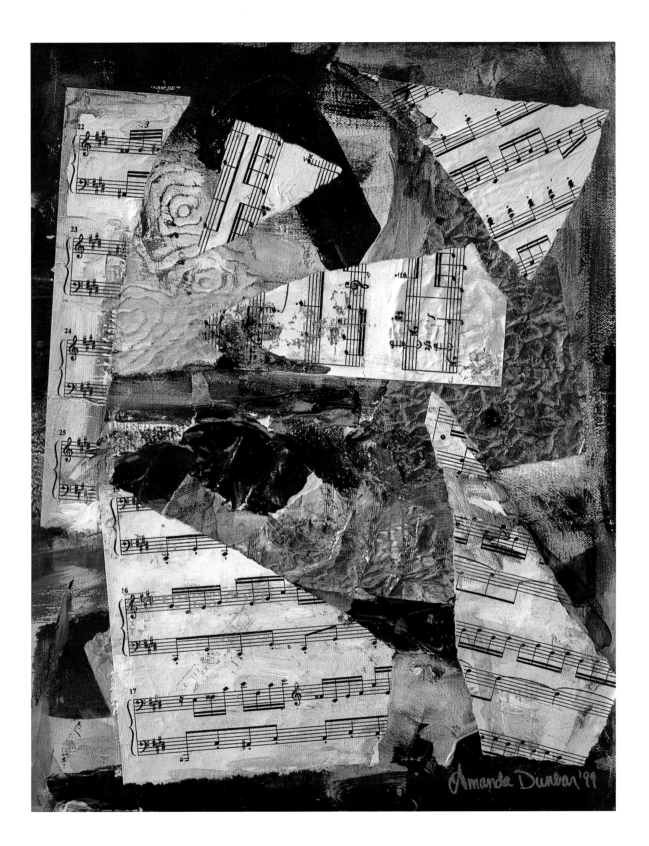

# CHAOS IN YELLOW AND BLUE

48 x 60, ACRYLIC ON CANVAS, 1999

*I created this painting at a time when I was feeling a lot of confusion and uncertainty. There were many crossroads at which I needed to make decisions and many conflicts that I needed to resolve. These difficult choices are represented by the crosses and changes in color. As my life has evolved, so has this painting. In many places, the colors blend and the crossroads have become softer and less important. It has been an exercise for me in growing and maturing.*

■  ■  ■

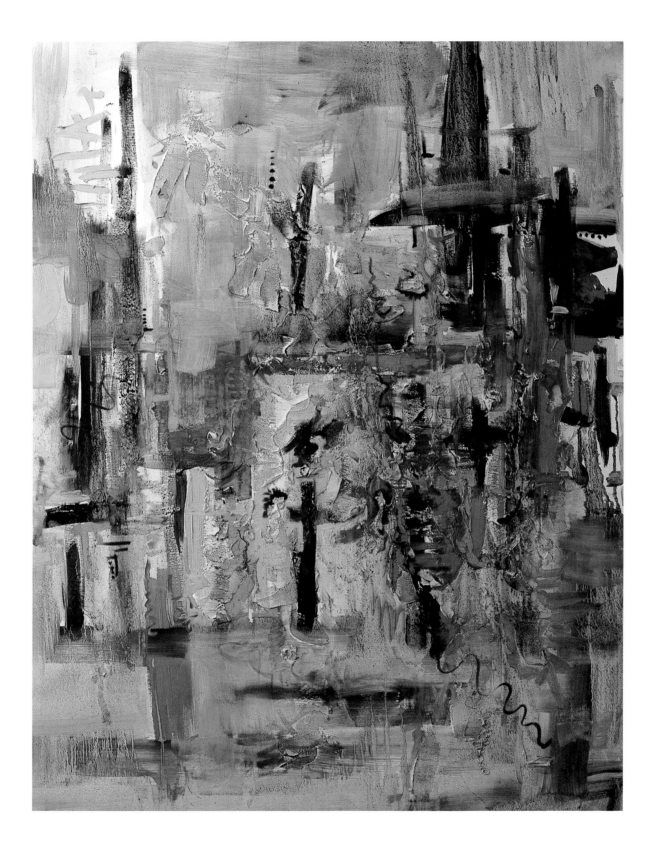

# HOT SAND

22 x 30, ACRYLIC ON CANVAS, 1999

*I love walking in the sand on the beach. In the summer the sand is hot and it is wonderful to play in. When Meaghan and I were small, we built sandcastles. I remember pouring the sand out of my pail and how it would catch the sunlight and sparkle different colors. In this painting I have depicted the heat in reds and the sparkles in blue, as they shine through the yellow sunlight. I have sprinkled in some of my special "hot sand."*

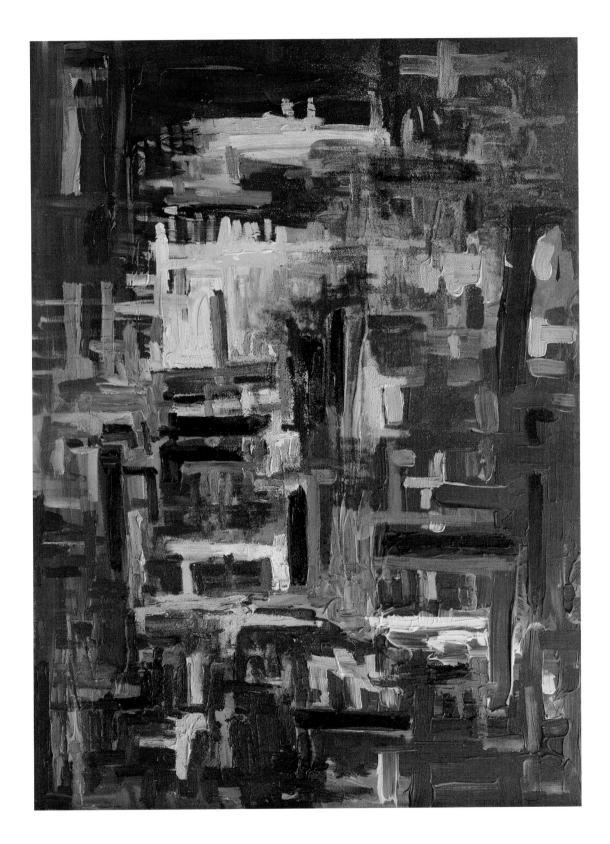

# EARTH

48 x 60, ACRYLIC ON CANVAS, 1999

*The following series of paintings are my representations of the elements. They are full of energy and life. As a group, each element depends on the others to support this wonderful creation that we are a part of, our earth. Each individual element is beautiful on its own, yet the symphony they produce together is exquisite. In this painting, earth is represented by all that is green and growing. It extends vertically with motion.*

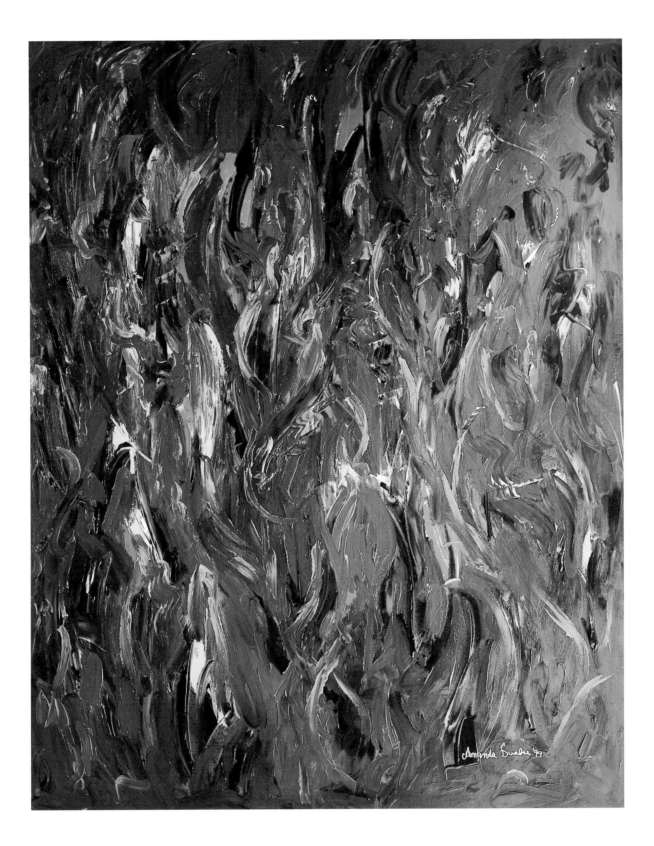

# WIND

48 x 60, ACRYLIC ON CANVAS, 1999

*Wind is the cleansing breath to the earth. It is soft yet powerful.*

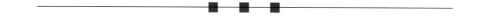

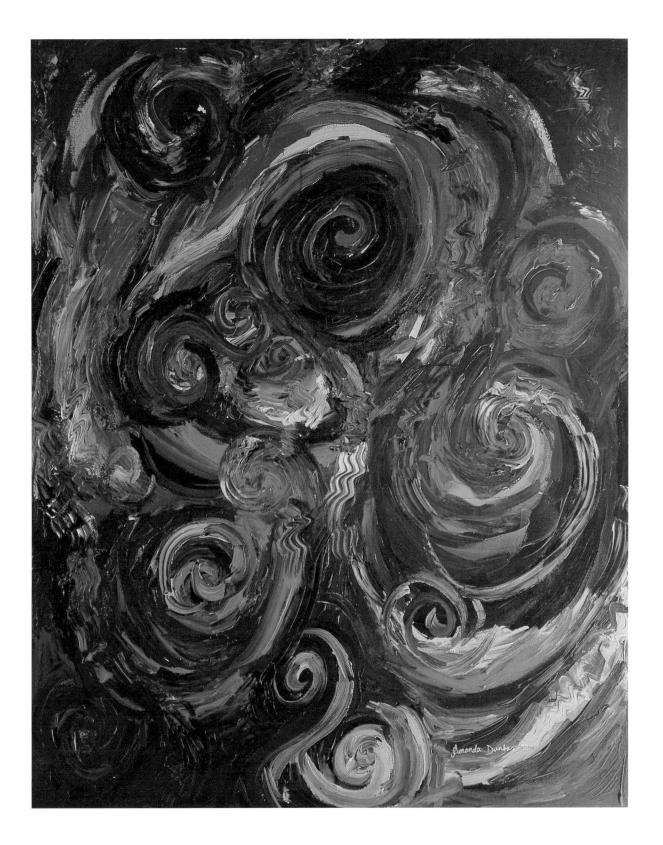

# FIRE

48 x 60, ACRYLIC ON CANVAS, 1999

*Fire is represented by the red and orange of flames. They lick and engulf; they are energy.*

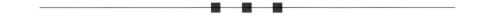

# SUN

48 x 60, ACRYLIC ON CANVAS, 1999

*Sun is bright, warm and renewing. It is the giver of vision and energy.*

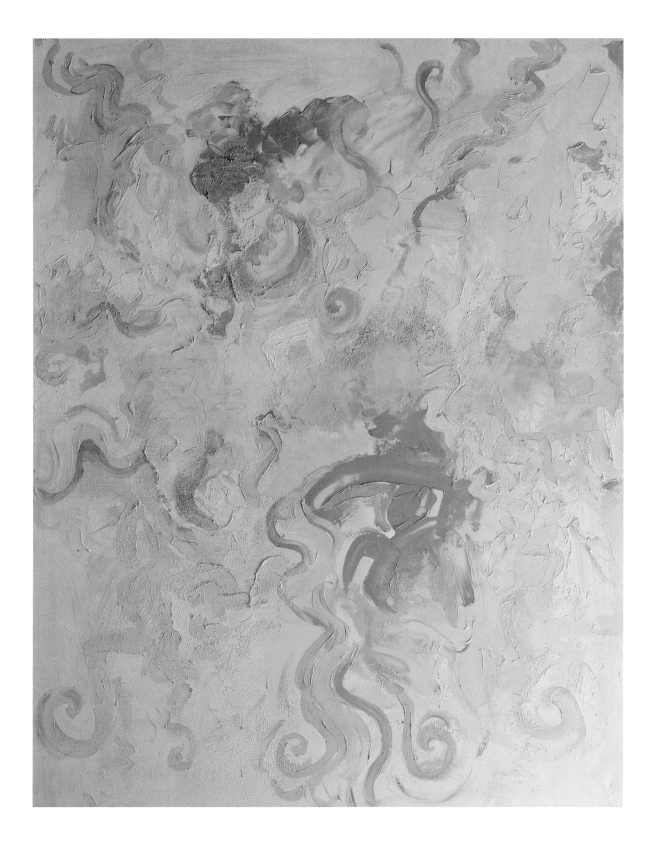

# WATER

48 x 60, ACRYLIC ON CANVAS, 1999

*Water is the cool, sometimes turbulent, but always beautiful, supporter of life. It is always changing, whispering and completely mesmerizing.*

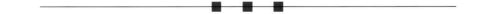

# STONE

48 x 60, ACRYLIC ON CANVAS, 2000

*Stone is heavy, solid and powerful. It contains a myriad of colors that can be subtle or strong, depending on how you look at it. It is one of nature's most interesting gifts.*

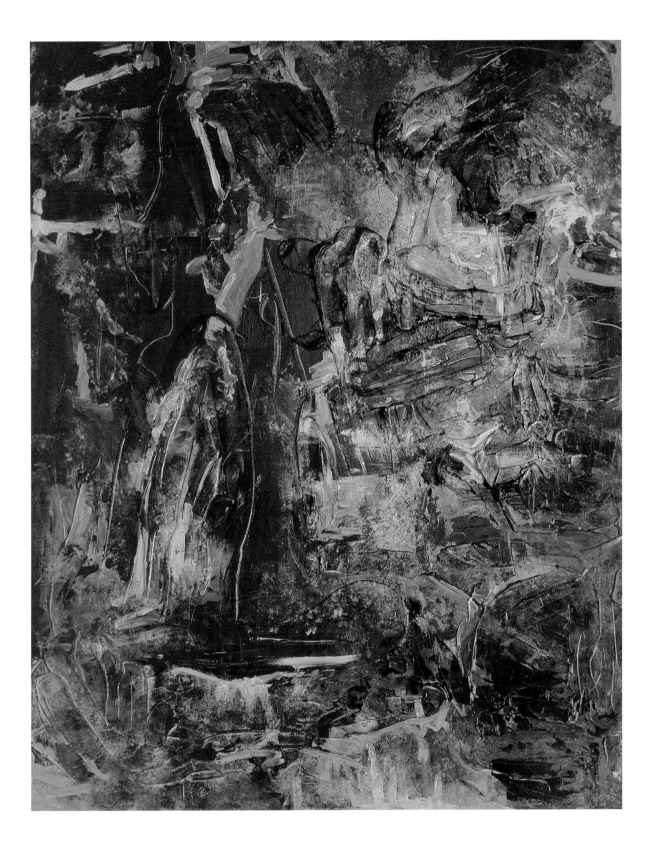

# STOP AND SEE
# THE FLOWERS III

48 x 60, OIL ON CANVAS, 2000

*In our busy lives, we just don't take enough time to really look at and enjoy things. Because flowers are one of my favorite subjects to look at, I decided to paint the parts and combinations I find most fascinating. I hope it will help someone else to slow down and really look at simple and beautiful things. There is so much to enjoy.*

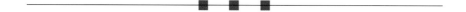

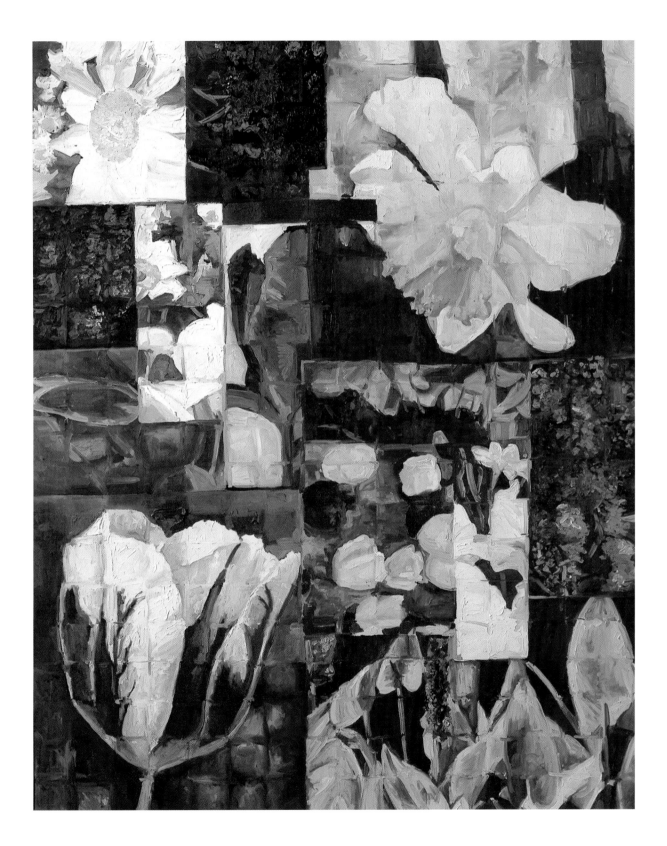

# NURTURING THE MIND

36 x 48, OIL ON CANVAS, 2000

*Children are like little sponges that absorb everything and anything they are exposed to. Reading to children is so important. To nurture a young mind is a wonderful thing. They need to be taught all that is positive so that they can succeed in life with compassion and conviction.*

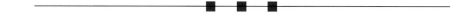

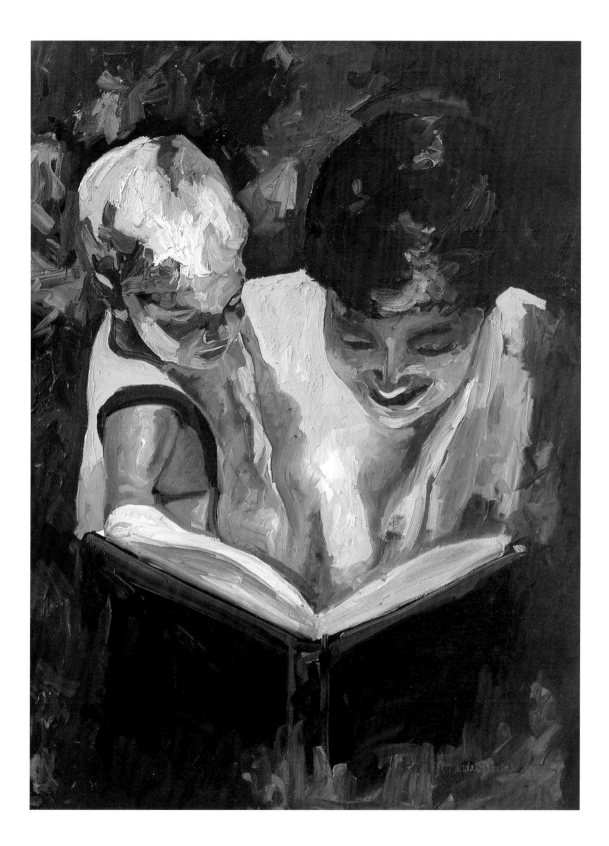

# COLUMBINE

48 x 60, OIL ON CANVAS, 2000

The tragedy at Columbine had a very profound effect on me, as it had on many people. I found myself thinking about it constantly. There had to be some lesson that we as teens and we as a nation could learn from it. Over the past year, I have watched an entire nation grieve. We have worked through denial, anger, fear and are nearing resolve. This incident changed my life. Although I can no longer enter my school without walking through a metal detector and I can no longer carry a school bag without it being searched, I realize that there really was a lesson to be learned. The nation truly pulled together. We have been given a wake-up call to teach our little children better and to spend time with them. We have been able to better seek answers to the problems of young people. Many good things came out of this tragedy. We as young people have been able to see just how important we are to the world; people really do care. I painted this piece because I was compelled to. It is based on a pyramid of hope. It displays the grief and anguish that was felt in the beginning. It then progresses to the intense thought and reflection (represented by the teenaged girl) that must always be a part of our actions, both to ourselves and to others. The doves represent the peace and hope that must be learned from such a grave situation. We have the ability to honor all those (directly and indirectly) involved with Columbine High by learning these lessons and ultimately teaching others. This is my tribute to Columbine and its message of hope.

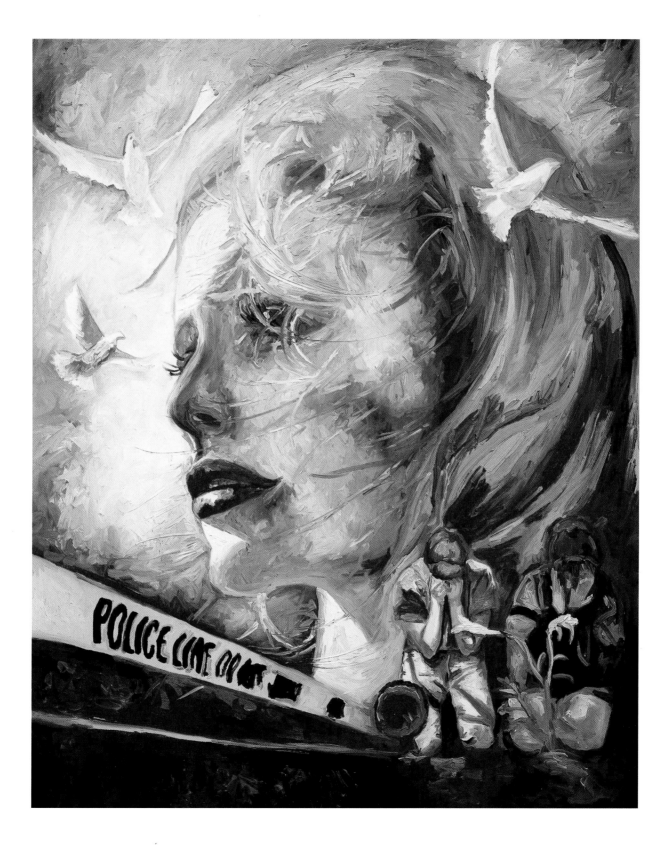